D1328111

IMAGES
of America

THE MILITARY HISTORY OF
NEW BEDFORD

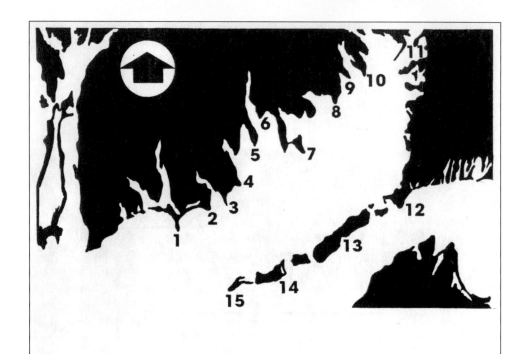

MILITARY INSTALLATIONS

1. GOOSEBERRY NECK
2. BARNEY'S JOY POINT
3. MISHAUM POINT
4. ROUND HILL
5. FORT RODMAN
6. FORT PHOENIX
7. WEST ISLAND
8. ANGELICA POINT
9. PEASE POINT
10. BUTLER'S POINT
11. CAPE COD CANAL
12. JUNIPER POINT
13. NAUSHON ISLAND
14. NASHAWENA ISLAND
15. CUTTYHUNK ISLAND

This map shows the military installations of the Harbor Defenses of New Bedford.

IMAGES
of America

THE MILITARY HISTORY OF
NEW BEDFORD

Christopher McDonald

ARCADIA

First printed in 2001.

Published by Arcadia Publishing,
an imprint of Tempus Publishing, Inc.
2A Cumberland Street
Charleston, SC 29401

Printed in Great Britain.

Library of Congress Catalog Card Number: 2001089670

For all general information contact Arcadia Publishing at:
Telephone 843-853-2070
Fax 843-853-0044
E-Mail sales@arcadiapublishing.com

For customer service and orders:
Toll-Free 1-888-313-2665

Visit us on the internet at http://www.arcadiapublishing.com

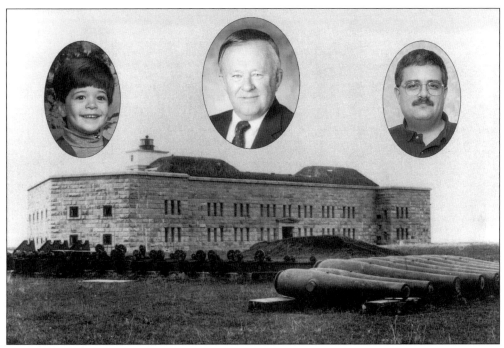

From 1934 to the present, there have been three members of the McDonald family involved with the military history of New Bedford. Pictured are James McDonald (center), past president of the Fort Taber Historical Association; Christopher McDonald (right), president of the Fort Taber Historical Association; and his son Matthew Christopher McDonald (left), future president of Fort Taber Historical Association.

CONTENTS

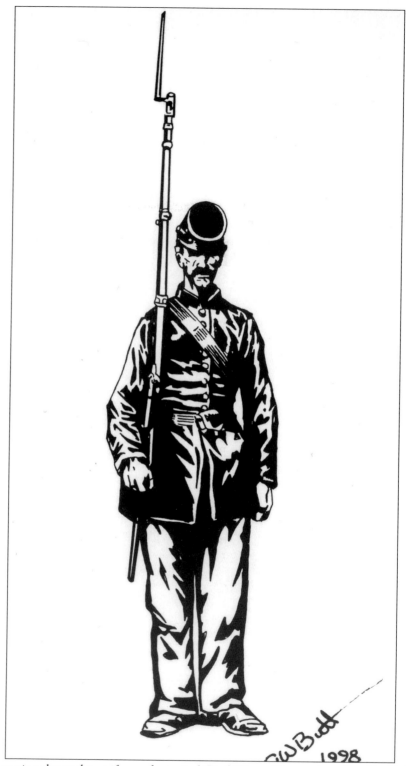

This illustration shows the uniform of a typical Civil War soldier stationed at Clark's Point.

INTRODUCTION

At the outbreak of the American Revolution, privateers used the Acushnet River as a launching platform from which sorties against English shipping were performed. During early September 1778, in consequence of these deeds, a large armed force of British troops landed upon Bedford (New Bedford) soil, and in the following hours, a small number of townsmen were shot, buildings were set afire, and goods on both sides of the river were destroyed. It was learned later that losses from this raid amounted to $500,000, a somber fact that convinced the citizens and merchants of Bedford that a defense system in conjunction with Fort Point (Fort Phoenix) was sorely required.

It was not until after the War of 1812 that an early earthwork was reportedly established at Clark's Point, a body of land jutting into Buzzards Bay, which commands all approaches into the harbor of Bedford. The earthwork mounted six obsolete muzzle-loading cannon and was located on a low-lying hill that overlooked the harbor approaches.

As late as 1840, a board of engineers met and planned a general defense operation of the Atlantic coast, of which New Bedford was considered to be of great importance. During 1842, chief of engineers Colonel Totten stated, "It (the earthwork) deserves no further expenditures," as this is a "very important harbor." Grants were extremely slow, however, and by 1846, only the plans and elevations were projected for a fort at Clark's Point.

One

THE CIVIL WAR

In 1846, Congress authorized an appropriation of $56,000 for a fortification in New Bedford. Two sites were chosen: Clark's Point and an island in the center of the harbor, called Egg Island. All that remained at Clark's Point was a rudimentary earthwork fort erected during the War of 1812, shown in this image. Final plans for a massive stone fortress were completed in mid-December 1848. A board of engineers met in Boston and included Col. Sylvanus Thayer, Capt. Robert E. Lee, and Maj. Richard Delafield, later considered the Father of American Seacoast Artillery.

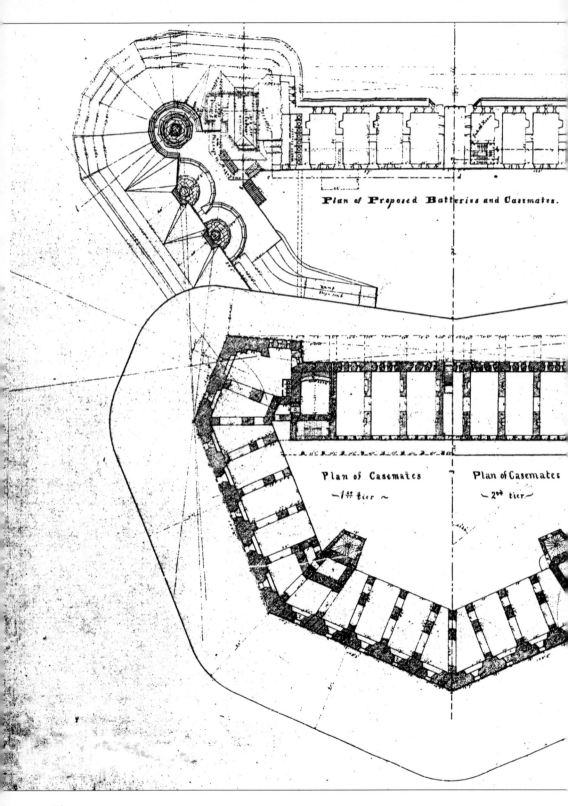

Plan of Proposed Batteries and Casemates.

Plan of Casemates
~ 1st tier ~

Plan of Casemates
~ 2nd tier ~

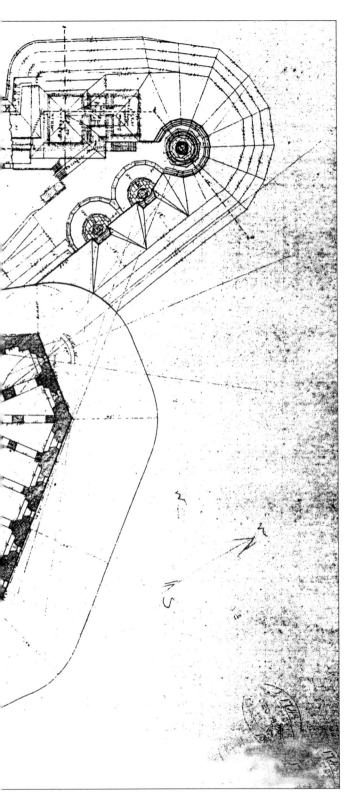

This image shows a plan of a fort projected by the board to occupy Clark's Point in New Bedford harbor, with ancillary works at Egg Island and Fort Point (Fort Phoenix). A three-tiered (level) work was projected with six lower-casemated quarters and seven upper-casemated quarters for officers, and the garrison with magazines, a central-balanced drawbridge in the gateway or sallyport (main entrance), and a moat.

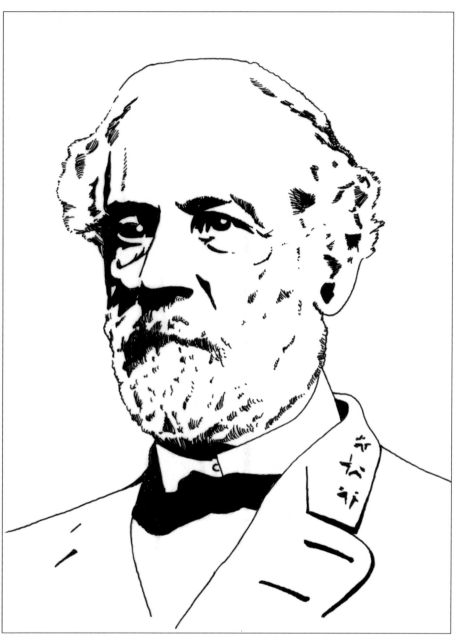

The military career of Gen. Robert E. Lee (1807–1870) began with his admission to the U.S. Military Academy. Commissioned as a lieutenant, he had the distinction of graduating second in his class, standing with the honor of not receiving any demerits while a cadet, which to this date has not been equaled. Assigned to the engineers, he helped with the construction of the St. Louis waterfront and coastal fortifications in Brunswick and Savannah. He also became involved in a seacoast fortification project with Maj. Richard Delafield in New Bedford. By mutual agreement, both officers recommended that a strong, multitiered work be situated at Clark's Point. This became excruciatingly concerning a few years later when the original plans for the fort at Clark's Point were misfiled. The individual most knowledgeable of the design and workings of the fort was now in command of all Confederate forces.

Brig. Gen. Richard Delafield (1798–1873) was the first U.S. Military Academy graduate to receive the merit class standing, placing first in the Class of 1818. Commissioned into the corps of engineers, he performed topographical engineering responsibilities and assisted with the plan and construction of East Coast fortifications, including New Bedford, Hampton Roads, New York, and the Mississippi Delta. He superintended repair operations on segments of the Cumberland Road, superintended the U.S. Military Academy on two separate occasions, oversaw New York and northern harbor fortifications, and was the chief engineer of the United States from 1864 to 1866.

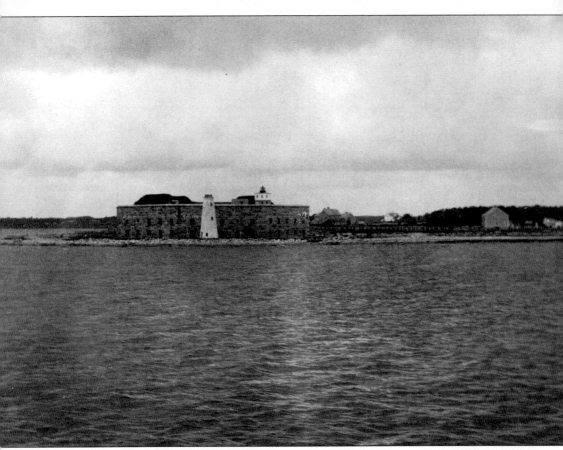

In 1857, Captain Benham of the U.S. Engineers conducted a site survey of Clark's Point for a massive, permanent fortification. The new work was to be constructed of New England granite and supplemented with brick vaults and arches. When completed, the fortress could bear all ordnance upon the main shipping channel approaching New Bedford, Fairhaven, and Dartmouth. If under bombardment, the fortress could bring direct fire upon New Bedford harbor (the Acushnet River) and Clark's Cove and simultaneously withstand siege and land force assaults. Cannon and flank howitzers covered all of the exterior points, and the rearward defense was supplemented with creneled scarp or musketry loopholes for riflemen. The basic design of the work, reestablished by American engineers after the Crimean War observations, was patterned after that of the noted French military engineer Sebastien Vauban. (Author's collection.)

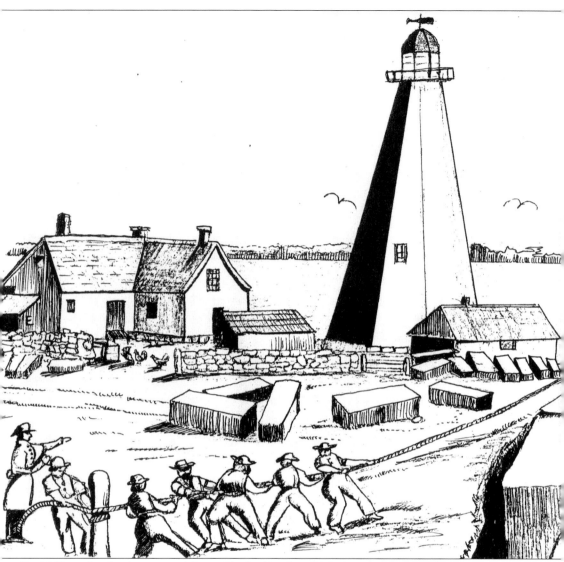

By 1859, under the direction of Capt. Charles Bigelow, U.S. Army, operations began at Clark's Point. Initial construction included a long wharf for the delivery of granite stone and foundation excavations for the fort. Shortly thereafter, huge 40-foot and 60-foot wooden derricks arrived and, after being set up, the granite blocks began to be delivered to the site by water barges. By December 1860, the wharf, the on-site railway for the stone transportation to the work site, and portions of the foundation had been completed.

Concerned for the unprotected position of New Bedford against Confederate sea raiders, Mayor Isaac C. Taber (1851–1862) and the city council formulated plans to defend the Whaling City's important port. An earthwork fort, begun by city laborers and volunteers, was completed in the spring of 1861. Dedicated with great fanfare on May 11, 1861, the earthwork was dedicated as Fort Taber, a name that has been applied to the site locally through the present date.

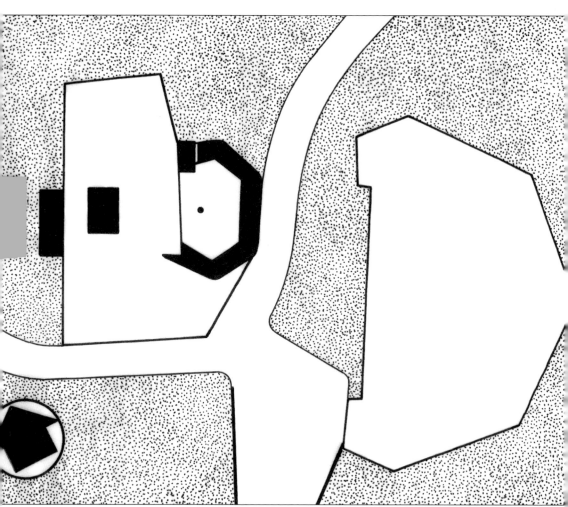

A 40-man artillery company of the New Bedford Home Coast Guards manned the ordnance at Fort Taber, which consisted of three 24-pound smooth bore and two 12-pound rifled cannons mounted on wooden carriages, protected by thick earth walls. Additionally, four companies of infantry of the New Bedford Home Coast Guards were assigned to both Fort Taber and Fort Phoenix.

Construction slowed at the site because of stone delivery and illness of the U.S. Army engineer in charge, Capt. Charles Bigelow. Because of his untimely death, Lt. Henry Martyn Robert (1837–1923), U.S. Military Academy 1857, was appointed overseer of construction. During his assignment at Clark's Point, Robert attended a number of meetings in New Bedford and found them without rules or protocol for speakers. He then formulated a protocol for parliamentary law, *Pocket Manual of Rules of Order for Deliberate Assembles*, published in 1876. In 1915, this became reworked as *Robert's Rules of Order Revised*. Robert worked as an army engineer until 1901, when he was appointed brigadier-general, chief of engineers, and he retired shortly afterward.

While construction of the fort at Clark's Point continued, military strategists created plans for a "Stone Fleet." The Stone Fleet was created on the basis that seagoing hulks, filled with stone and debris, could be towed to a southern port, placed in the desired position, have their sails removed, have their spars cut away, and have the ships scuttled and sunk. The captains and crews would return in safety to New Bedford. After the sailing of the Stone Fleet to blockade southern harbors, the Confederate raiders pledged and reserved a special and sincere antipathy for New Bedford, its whaling fleet, and Yankee sailors. A strict watch was kept for the Confederate raiders, the *Merrimac*, the *Shenandoah*, and the *Alabama*, by the guards and workmen, as construction progressed at the site.

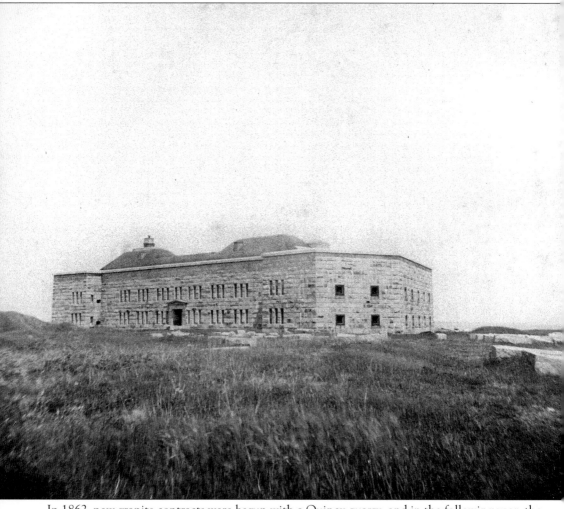

In 1862, new granite contracts were begun with a Quincy quarry, and in the following year, the second tier of the granite fort was begun. During the summer, 10 casemate-mounted guns were installed at the fort in the event of an attack by Confederate raiders. By 1864, the first tier (level 1) was completely finalized and the second tier was completed to design. Twenty-four gun rooms and two flank howitzer chambers were finished and ready to receive their weapons. In April 1864, the garrison was ordered to Washington, and in August of that year, Capt. Henry Martyn Robert requested transfer due to poor health.

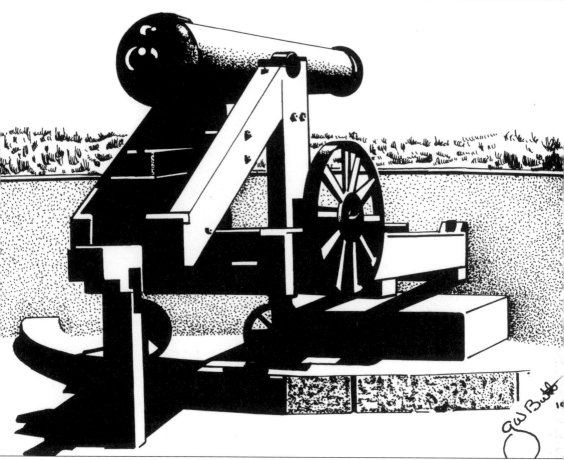

By September 1864, Fort Taber had been rendered useless because of the height of the walls of the permanent granite fort in front of it. The guns were removed, the powder stored, and the garrison dismissed. The earthwork was leveled, and Fort Taber no longer existed. This image depicts the type of weaponry mounted in Fort Taber before its termination.

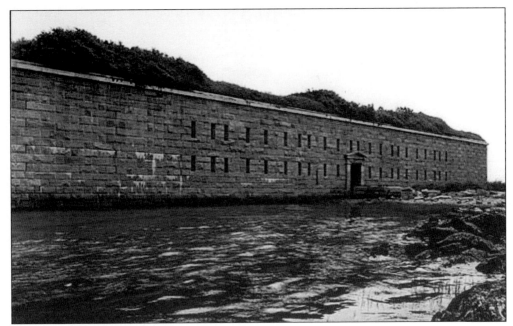

A similar granite fort was constructed in 1857 on Hog Island Ledge in Portland Harbor, Maine. Similar in design and appearance to the fort at Clark's Point, this work was never fully completed. Unlike its New Bedford sister fort, however, it did receive a name: Fort Gorges. (National Archives.)

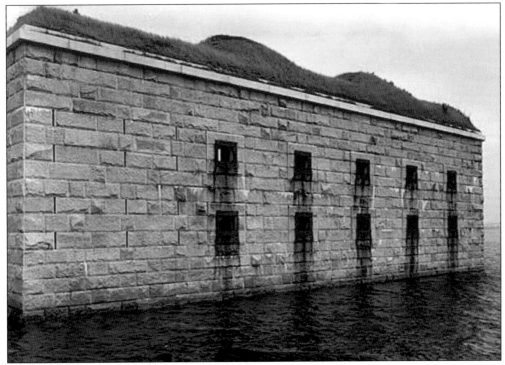

This view shows the exterior wall of Fort Gorges and the formidable casemated gun ports. (National Archives.)

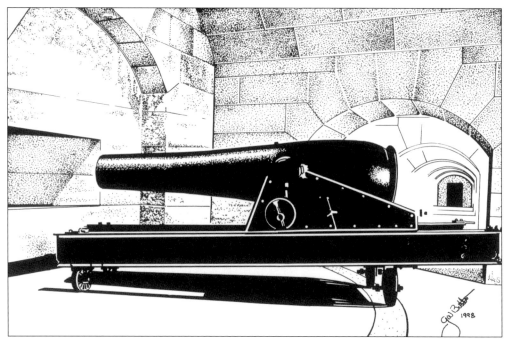

In 1865, the first flank howitzer was mounted, and 26 ten-inch and eight-inch Rodman cannons mounted on iron carriages were received, some being installed as shown in this illustration.

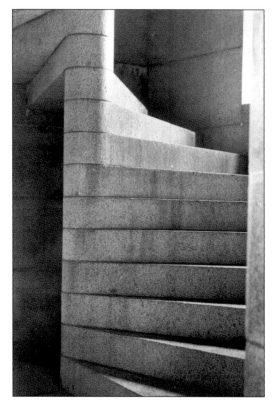

In April, the circular stairwells were completed, and by October, work progressed to such extent that five wooden derricks were in constant use, placing stones at the fort. (Author's collection.)

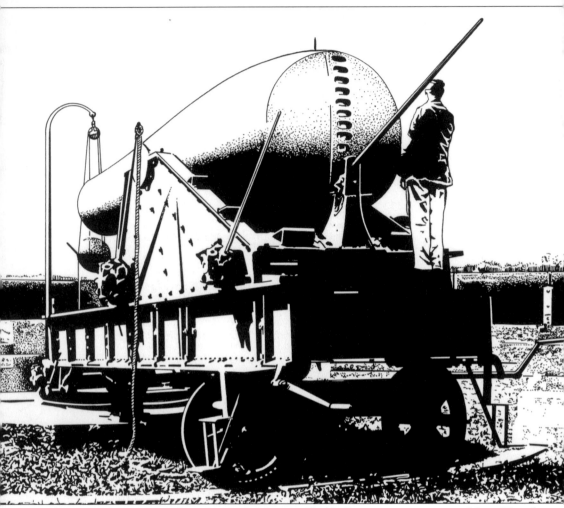

The original armament design atop the fort at Clark's Point was to consist of five 15-inch Rodman cannons and eight 10-inch Rodman cannons. Shown is a typical 15-inch Rodman cannon (modified).

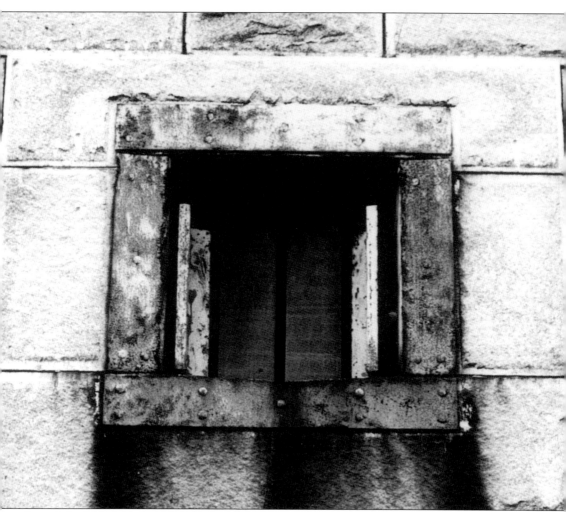

One of the first examples of protecting seacoast fort gun crews under enemy gunfire were iron shutters installed in the gun room embrasures at certain defensive works. During an engagement, the hinged iron shutters were closed, protecting the gunners and gun rooms from enemy gunfire, shrapnel, or sharpshooters. When the gun was run out, the barrel would push the iron doors (shutters) open, the gun would fire, and the recoil would bring the gun back to its loading position, while the embrasures shutters would snap shut. This type of armored shutter, known as a Totten embrasure, was extensively installed in the gun rooms of the fort at Clark's Point. This was the solitary fort in Massachusetts and one of the very few in New England equipped with this system.

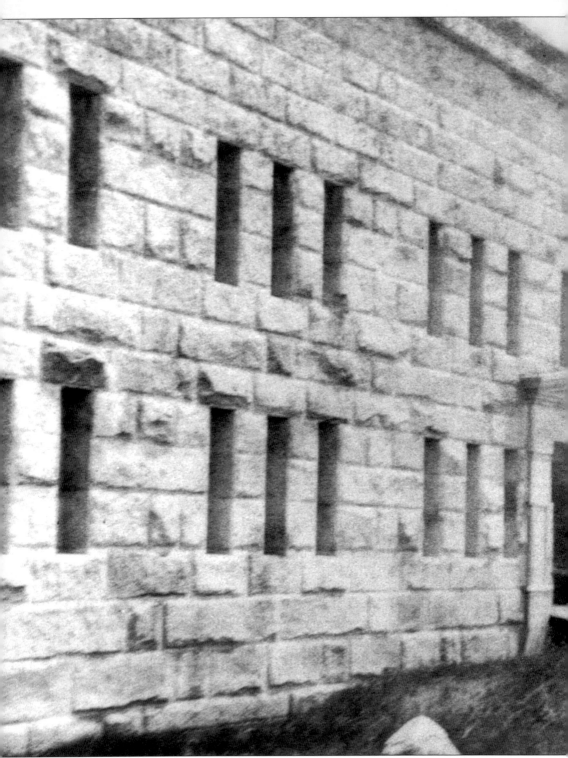

This is a view of the back of the fort at Clark's Point, after construction was stopped. Notice the granite blocks and the drawbridge leading into the sally port. The plans of the fort at Clark's

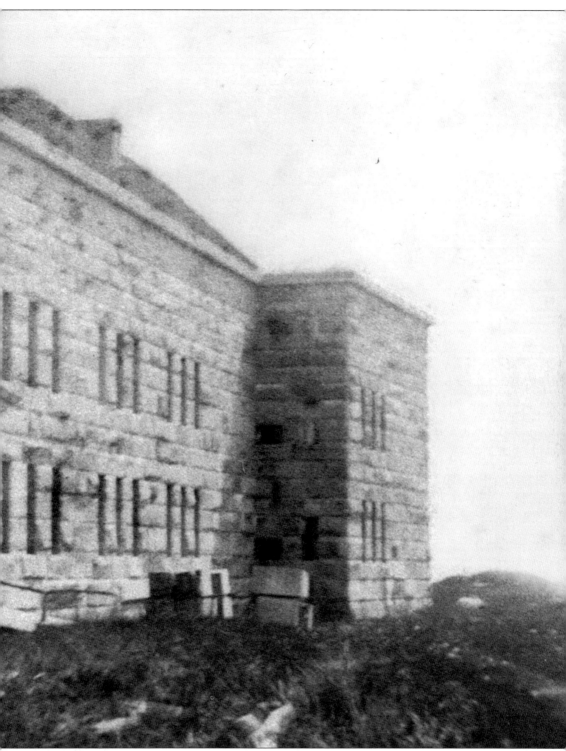

Point were to have a moat around the perimeter, with a balanced drawbridge leading into the fort. (U.S. Army Military History Institute.)

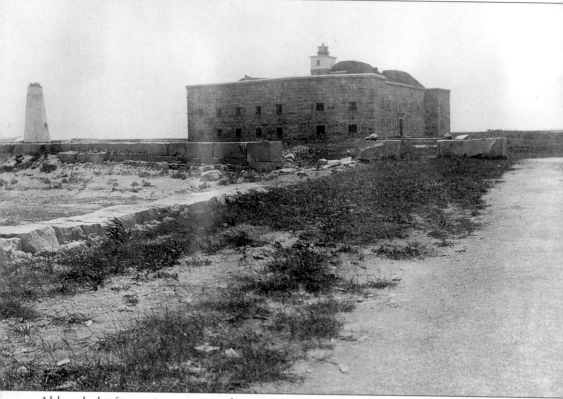

Although the fort project terminated in 1869, windows and doors were installed and pointing of the stonework was completed during the year. However, serious dampness in the magazines and storerooms became evident, and armament and technological developments made during the Civil War thwarted any hope that the third and final tier of the fort would be completed. (Author's collection.)

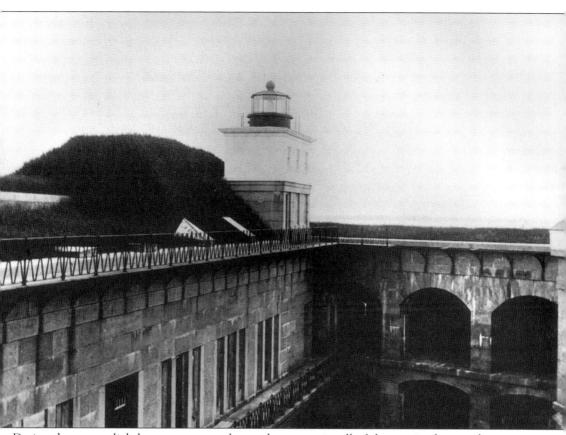

During the year, a lighthouse was created atop the rear stairwell of the granite fort, rendering the original lighthouse, located in front of the fort, obsolete. (Author's collection.)

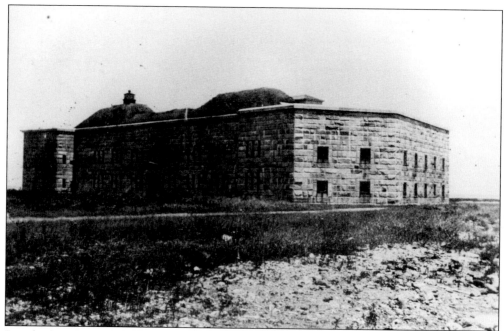

Rapid advances in ordnance and new methods of coastal defense versus naval attacks soon rendered the project at Clark's Point completely terminated by 1871. The rearward defenses were never begun, and the unnamed fort was placed on caretaker status, to be used in an emergency only. (Author's collection.)

At this time, the foundations atop the upper tier were waterproofed and covered with earth. The following ordnance was mounted or on hand at the site: twenty 10-inch Rodman, M-1861 (plus seven not mounted); fourteen 8-inch Rodman, M-1861 (plus two not mounted); four 100-pound Parrott, rifled; one 24-pound howitzer, flank defense; six 15-inch Rodman, M-1861 (not mounted). (Author's collection.)

Two

THE WAR OF 1898

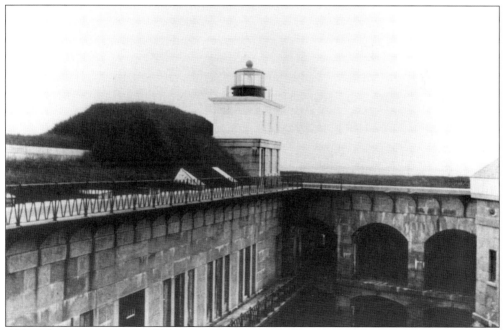

Although this view of the Old Stone Fort at Clark's Point was taken in 1899, it shows the general conditions during the War of 1898. (Author's collection.)

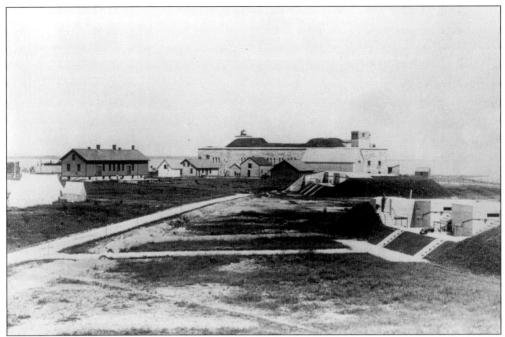

This view of Fort Rodman shows the Old Stone Fort at Clark's Point and two of the newly constructed gun batteries, Battery Craig and Battery Cross, to the immediate right. (Author's collection.)

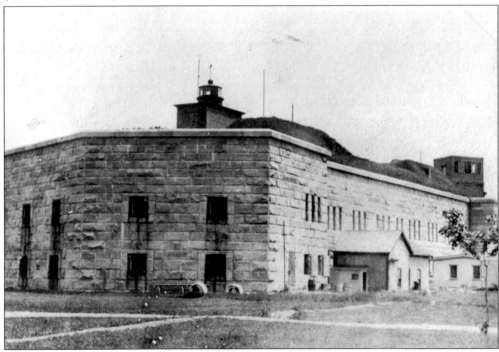

Prior to the hostilities of the War of 1898, the fortress was to be a public park for the residents of New Bedford. It was at this time that the mining (torpedo) casemate was created within the first and second tiers of the northeastern bastion of the stone fort. (John Bowen collection.)

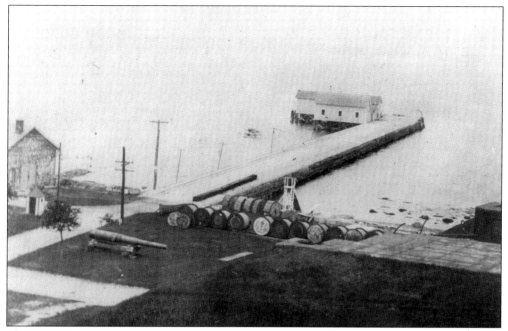

This is a view of the mine storeroom with the pier and boathouse. Notice the rolls of cable used for the mines, which were placed in Buzzards Bay. This view was taken from the top of the Old Stone Fort, showing the top of Battery Walcott with an extra eight-inch gun tube on blocks. (John Bowen collection.)

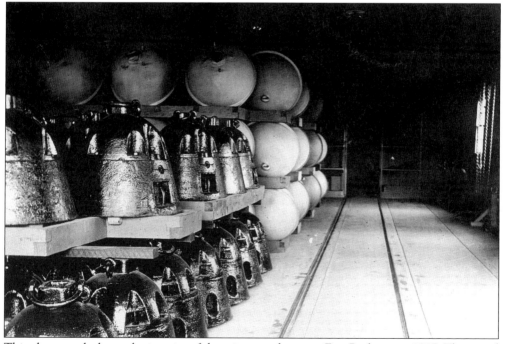

This photograph shows the interior of the mine storehouse at Fort Rodman, c. 1917. The round objects are the mines, and the objects in the front are anchors that hold the mines in the water. (*New Bedford Standard Times.*)

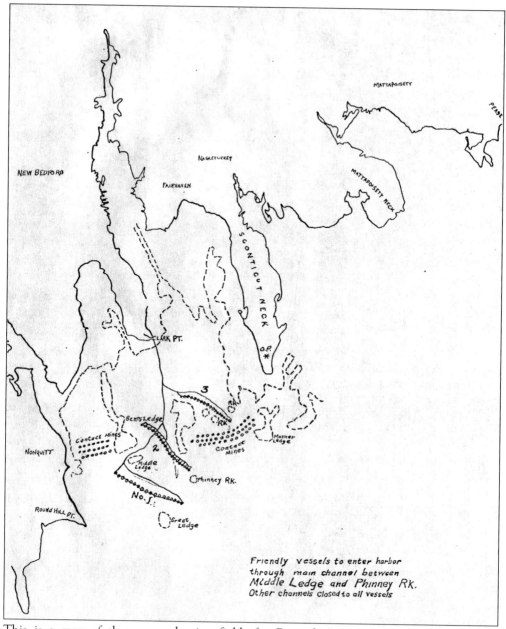

This is a map of the proposed mine fields for Buzzards Bay and New Bedford harbor. (National Archives.)

With the sinking of the USS *Maine*, the concept of a public park soon faded. On May 6, 1898, a detachment of 30 men from the 2nd Artillery Regiment, Fort Adams, Newport, Rhode Island, arrived at the fort for guard and patrol duty.

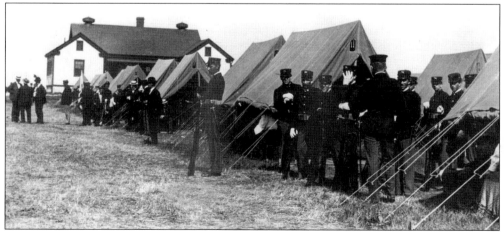

On June 1, 1898, Batteries G and L of the Massachusetts Volunteer Militia (MVM) arrived at the fort. Tents were erected to the rear of the fortress, and the garrison immediately turned to cleaning and repairing the site.

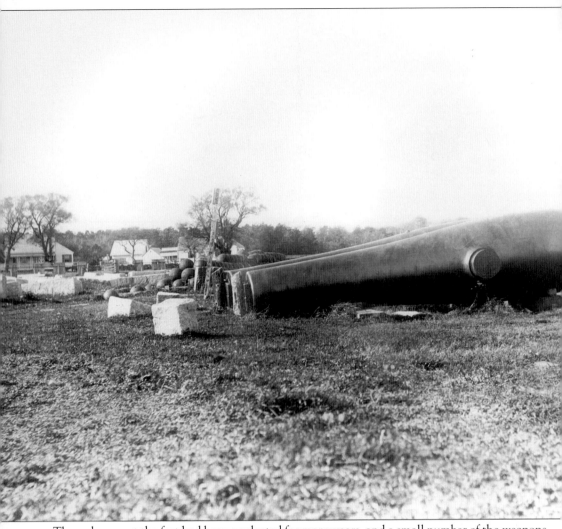

The ordnance at the fort had been neglected for many years, and a small number of the weapons had the priming wire firmly rusted and fixed in the vent. The artillerymen repaired and reamed out the choked holes, and the pieces were brought into first-class condition once again. However, an enterprising New Bedford newspaperman built a lurid story of "spiked guns" and "Spanish spies" about the incident, and the tale made the rounds of the local papers, causing infinite disgust to the garrison and endless amusements to the remainder of the regiment. Rumors of Admiral Cervera's fleet lurking off the New England coastal cities and towns ran rampant, and fishing boats and dories making their way through early morning mist were oft mistaken for advance elements of the fleet by anxious sentinels on patrol duty at the fort.

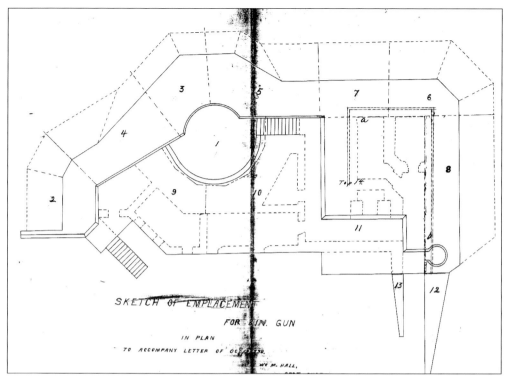

SKETCH OF EMPLACEMENT
FOR 8 IN. GUN
IN PLAN
TO ACCOMPANY LETTER OF OCT 9 1890.
WE M. HALL,

It was during this period that construction of newer more powerful rifle batteries were begun at the site surrounding the old stone fortress. Two eight-inch rifles, model of 1888, were mounted on the new disappearing carriages, and a concrete emplacement was built for each unit as shown in this plan. Lesser caliber gun batteries were also begun at this time. The smaller rapid-fire batteries ranged in caliber from fifteen-pounder (three-inch) to five-inch and had the sole task of defending the mine fields of New Bedford harbor and thwarting attacks by monitor craft and landing parties. (National Archives.)

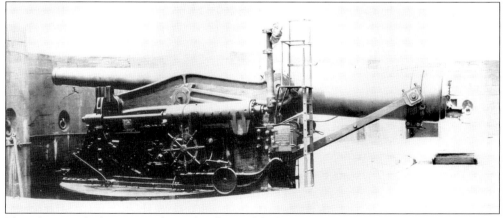

This photograph shows an eight-inch rifle, model of 1888, mounted on a disappearing carriage in the loading (down) position, similar to Fort Rodman guns. (Marty Dwyer collection.)

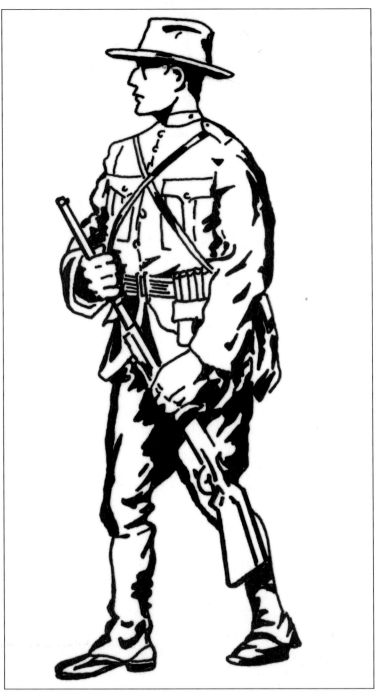

During July 1898, the fortress and the site received its long-awaited name: "By General Order from Army Headquarters, dated 23rd July [1898] the post was officially named 'FORT RODMAN' in honor of the memory of Lt. Colonel William L. Rodman, 38th Massachusetts Infantry, who fell at the head of his regiment in the assault on Port Hudson in 1863. Thus, after waiting forty-one years for a name, the old fort at last received that of a Massachusetts soldier while a garrison of Massachusetts Volunteers was on duty to assist at its christening."

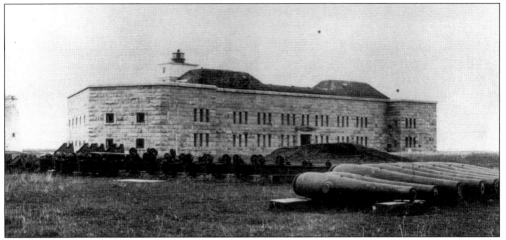

On September 19, 1898, Batteries G and L departed from Fort Rodman, marking the terminus of manned casemated cannon within the fortress. By 1899, modifications were proposed to the work and interior sections and finally, during 1902, the unit was transferred to the Heavy Artillery Corps. At the turn of the century, all of the obsolete cannons and carriages had been removed from the site.

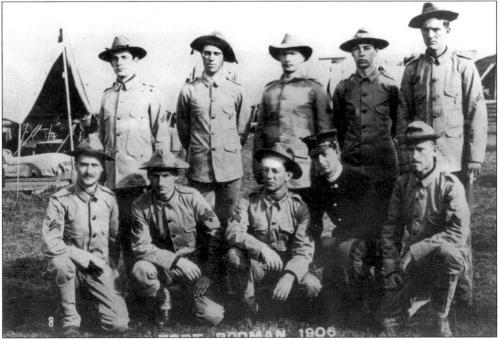

The fort was shortly thereafter placed on a caretaker basis, with a small body of troops to ensure the protection of ordnance and federal property. At this time, the remainder of the modernized seacoast artillery and emplacements were completed. Ordnance mounted at the fort at this time was as follows: Battery Walcott, one eight-inch rifle, M-1888 mounted on an M-1869 disappearing carriage; Battery Barton, one eight-inch rifle, M-1888 mounted on an M-1869 disappearing carriage; Battery Craig, two three-inch rapid-fire, installed on pedestal mounts; Battery Cross, two five-inch rapid-fire, installed on pedestal mounts; Battery Gaston, two three-inch rapid-fire, installed on balanced-pillar mounts.

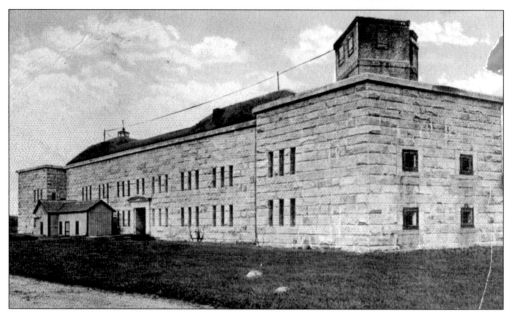

Modifications were made to various systems and armament from this point until the period of the World War I. Mounted upon its parapet, the stone fortress had a modern seacoast surveillance station and a powerful seacoast searchlight unit, capable of illuminating a target at a distance of 8,000 yards.

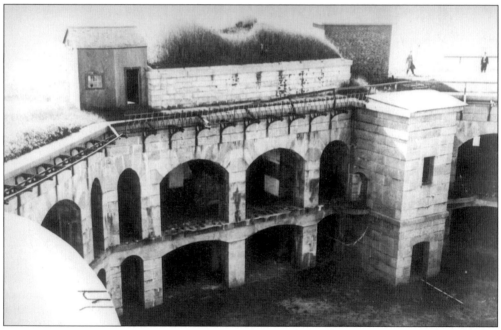

On December 8, 1913, the shelter for the 24-inch searchlight, which was built on the south side at the top of the old stone fort, was blown down. It was requested that immediate steps be taken to replace the shelter. In February 1917, the 24-inch searchlight was changed to a 60-inch General Electric type in the existing wooden building, later changed to brick. The searchlight shelter is to right of this picture. (Author's collection.)

Three

WORLD WAR I

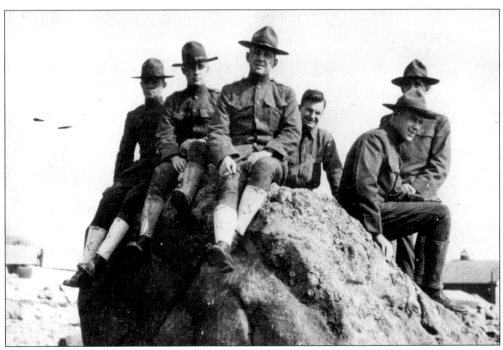

At the outbreak of the U.S. involvement in World War I, the armament at Fort Rodman was reworked and readied for use. Wooden barracks were quickly constructed and hundreds of pup tents covered the field. During the war, elements of the 1st and 2nd Companies, New Bedford, were stationed at the fort. Many men were assigned to coast artillery units and regiments training in Boston Harbor forts from Fort Rodman at this time. These units were later compiled into entire regiments serving the American Expeditionary Force (AEF) in France for the duration of the war. On September 1, 1919, the 2nd Company, Fort Rodman, then became the 1st Company, New Bedford Coast Artillery Corps. Six of these soldiers pose for a group photograph on a rock near a sea wall, close to the old stone fort and the mine storeroom building. (John Bowen collection.)

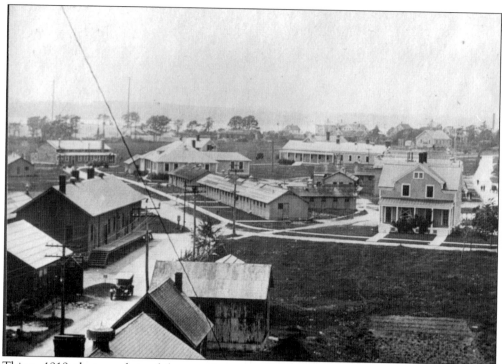

This c. 1919 photograph is of the post from atop the old granite fort at Fort Rodman. (John Bowen collection.)

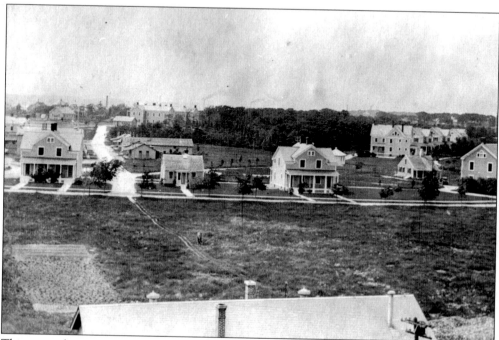

This is another view of the post from atop the old granite fort. Officers Row is on the right. (John Bowen collection.)

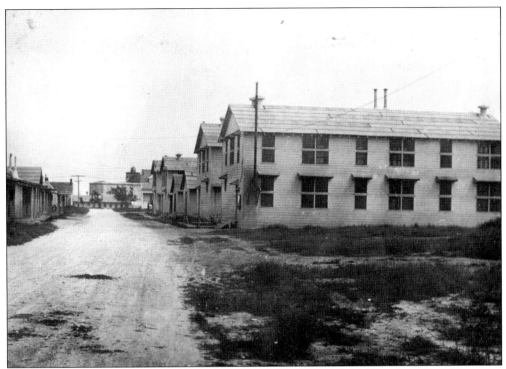

This is a *c.* 1919 view of the cantonment area at Fort Rodman. In this image, the old granite fort is visible at the very end of the company street. (John Bowen collection.)

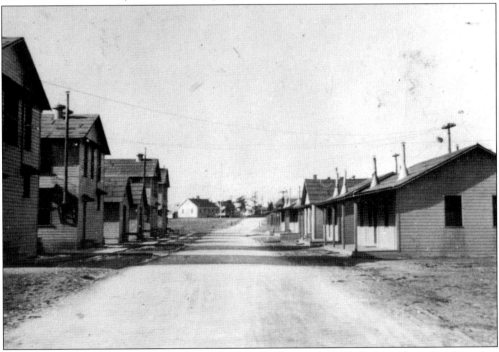

This is a reverse view of the above image at Fort Rodman, *c.* 1919, looking from the direction of the old granite fort. (John Bowen collection.)

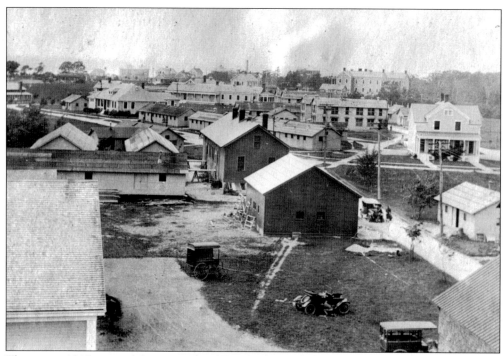

This is a *c.* 1919 view of the west side of Fort Rodman. (John Bowen collection.)

This is a *c.* 1919 view of Officers Row at Fort Rodman. (John Bowen collection.)

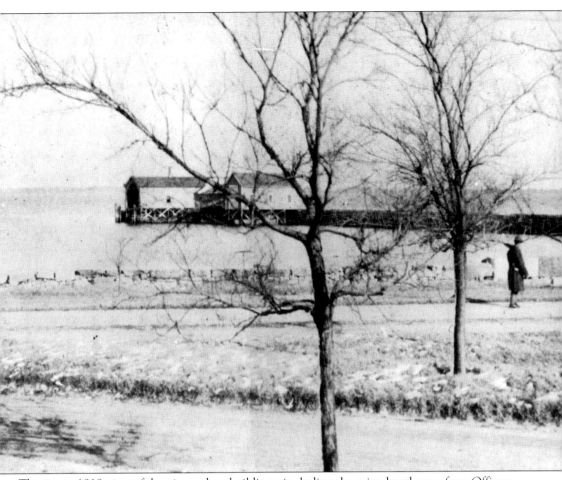

This is a c. 1919 view of the pier and outbuildings, including the mine boathouse, from Officers Row at Fort Rodman. Notice the solitary sentinel (right) on patrol. (John Bowen collection.)

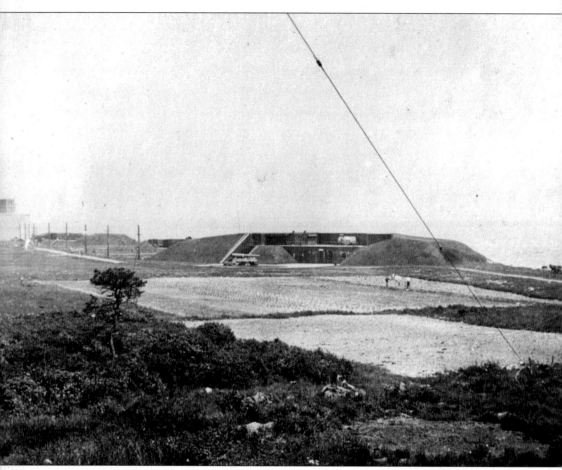

This *c.* 1919 photograph is of the main line of fortifications at Fort Rodman. They are, from left to right, the following: Battery Cross, Battery Craig, and Battery Barton. (John Bowen collection.)

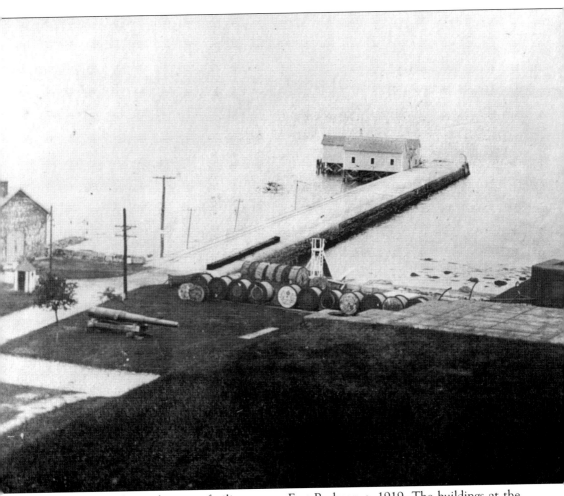

This photograph shows the mine facility area at Fort Rodman *c.* 1919. The buildings at the termination of the pier are for small mine yawls (boats). The ordnance or torpedo (mine) storage building is located to the far left. Notice the reels of cables near the pier. Also, notice the eight-inch gun tube for Battery Walcott. (John Bowen collection.)

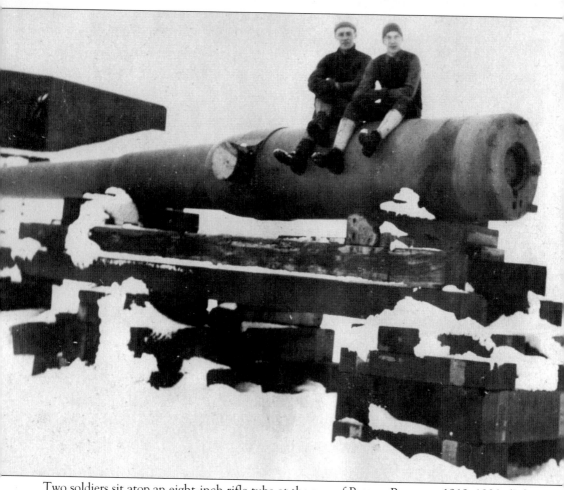

Two soldiers sit atop an eight-inch rifle tube at the rear of Battery Barton *c.* 1919–1920. (John Bowen collection.)

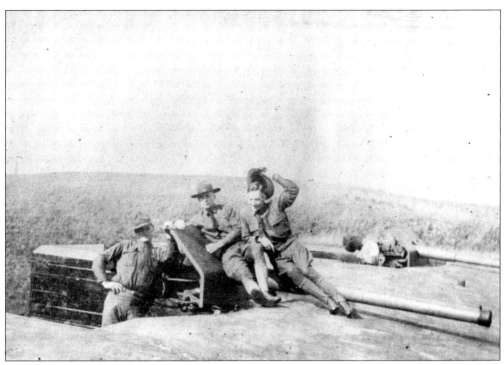

These two views show three soldiers relaxing on a gun and a shield of the three-inch rapid-fire gun battery, Battery Craig, at Fort Rodman *c.* 1919. (John Bowen collection.)

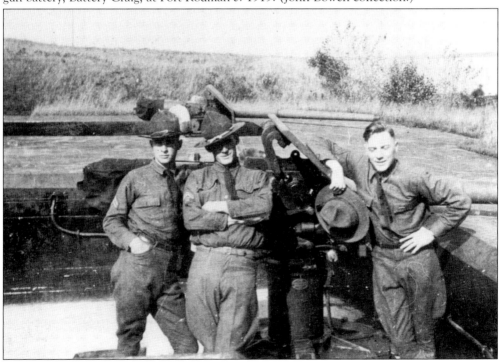

This is a photograph of Battery Milliken (12-inch breech-loading rifle) under construction *c.* 1920. The main barracks are to the rear. (John Bowen collection.)

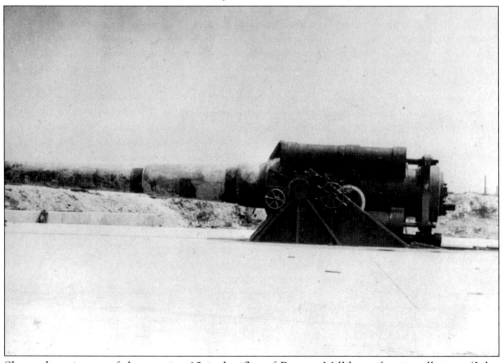

Shown here is one of the massive 12-inch rifles of Battery Milliken after installation. (John Bowen collection.)

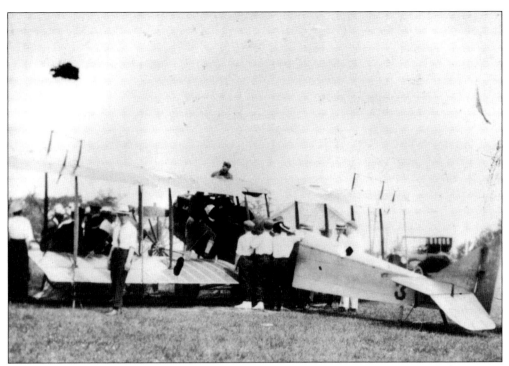

These two images show a bi-wing airplane that landed at Fort Rodman *c.* 1919. (John Bowen collection.)

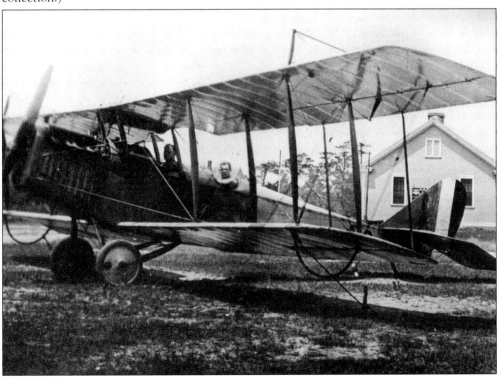

Shown here is a soldier on guard duty at Fort Rodman *c.* 1919. (John Bowen collection.)

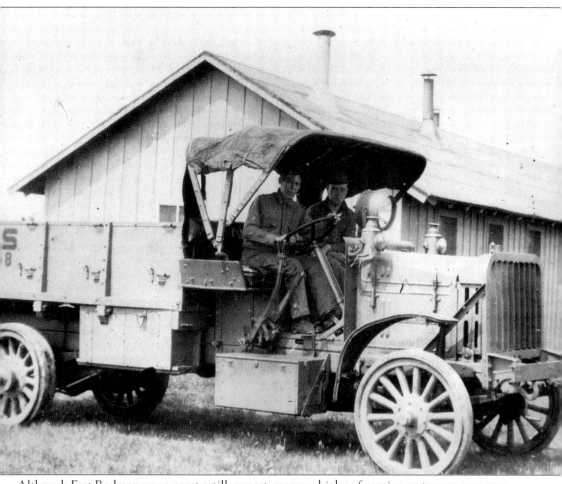

Although Fort Rodman was a coast artillery post, many vehicles of varying sorts were necessary. This photograph was taken *c.* 1919. (John Bowen collection.)

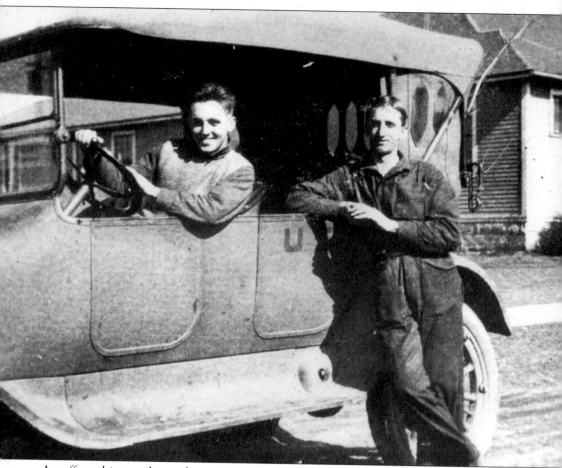

A staff car driver and a mechanic pause on a sunny day *c.* 1919. (John Bowen collection.)

Incidents of German submarines cruising off the New England coast and the ill-fated drama of the *Perth Amboy* off Cape Cod kept the anxious guard and beach patrols alert until the close of the war. This illustration depicts a German U-boat on the high seas. (Gerald Butler.)

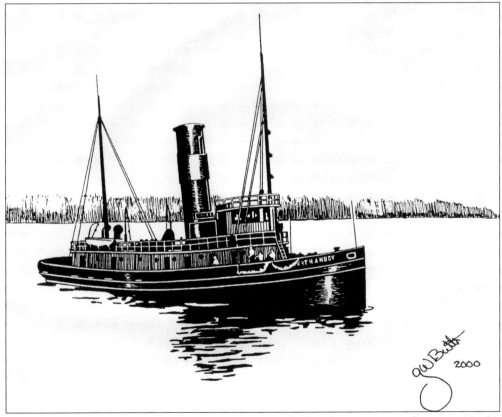

Shown here is the *Perth Amboy* before the attack by the German submarine U-156. (Gerald Butler.)

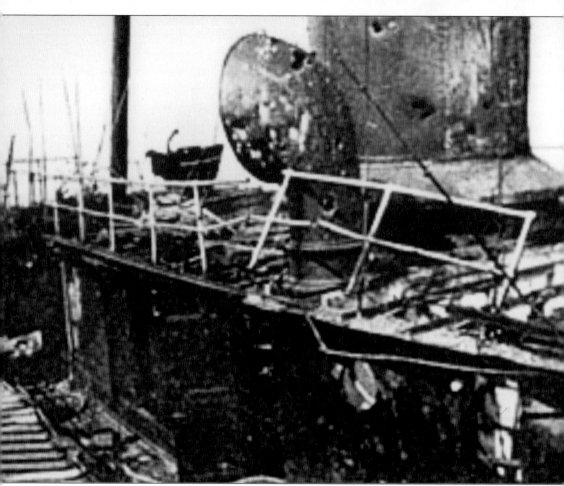

The *Perth Amboy* incident took place three miles off Orleans on Cape Cod. This action later became known as the battle of Orleans and brought unrestricted submarine warfare to the Massachusetts shore. The attack was at 10:30 a.m. on Sunday, July 21,1918, when the tugboat *Perth Amboy* towing four coal barges was attacked by the German submarine U-156. Hiding in a fog bank, the U-156 began torpedo and deck-gun action against the unarmed tugboat and barges. One barge was immediately sunk. Minutes later, shore-based Coast Guard station observers reported gunfire and explosions but were unable to see anything due to the thick fog. The U.S. Navy Air Station at Chatham was notified and sent two armed flying boats to the area, while naval headquarters in Boston and Rhode Island immediately issued orders for all submarine chasers, patrol boats, and the submarines N-1 and N-2 to form a large antisubmarine force and seek out the German submarine. Shore observers now reported that the three barges and the tug were on fire and the two U.S. Navy flying boats were overhead. The tugboat remained afloat but burned throughout the night. The battle of Orleans lasted one and a half hours, resulting in the sinking of four barges and severe damage to the *Perth Amboy*, as shown in this image. (Author's collection.)

Four

THE POSTWAR ERA

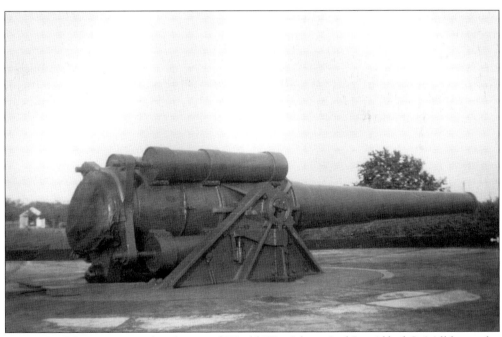

Battery Milliken was named in honor of World War I hero 2nd Lt. Alfred S. Milliken, who served with the 6th Engineers and was the first officer from New Bedford killed in action during World War I. Milliken was killed in France on March 30, 1918. The battery was constructed in the early 1920s and housed two 12-inch rifles mounted on a barbette carriage. The rifles had a range of 16 miles and provided protection for all of Buzzards Bay. The picture above is one of the 12-inch guns at Battery Milliken, before it was casemated in 1941. (Author's collection.)

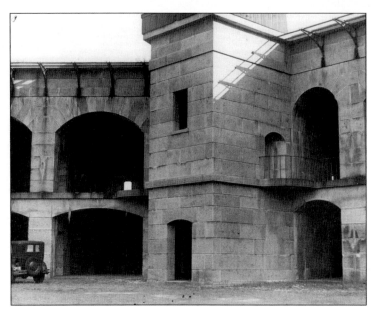

In 1935, the Works Project Administration (WPA) recommended that the old stone fortress be dismantled and the granite blocks be utilized for cemetery walls within the New Bedford area. However, the widow of Gen. Philip Sheridan was instrumental in saving the fortress for historical purposes. This interior view shows the old granite fort, with the car owned by the caretaker of the fort. (Author's collection.)

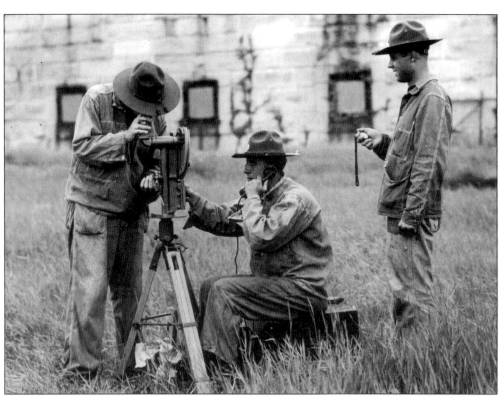

The post often saw National Guardsmen and regular army troops using the machine gun and rifle ranges pre-World War II. In this c. 1938 image, Pvt. Sumner Silberman of Providence, Rhode Island, Cpl. Joseph Gagnon, and Pvt. Joseph Sylvain of Fall River are seen operating an altimeter to determine the altitude of an antiaircraft target. (*New Bedford Standard Times.*)

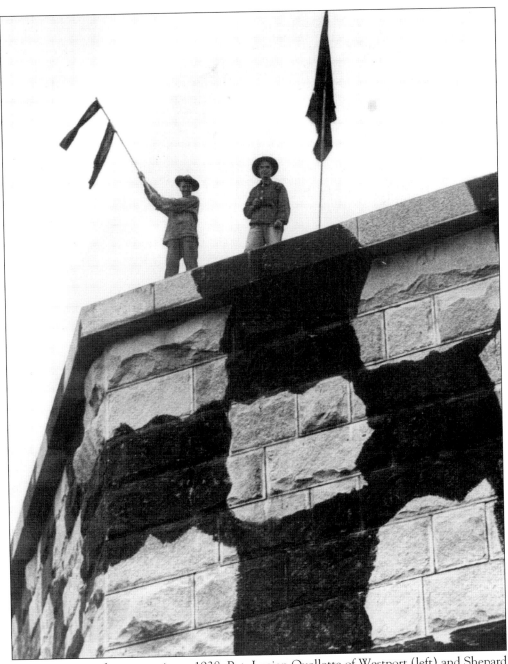

During antiaircraft gun practice *c.* 1938, Pvt. Lucien Quellette of Westport (left) and Shepard Crane of Newton signal to the men on a boat to release a target balloon. (*New Bedford Standard Times.*)

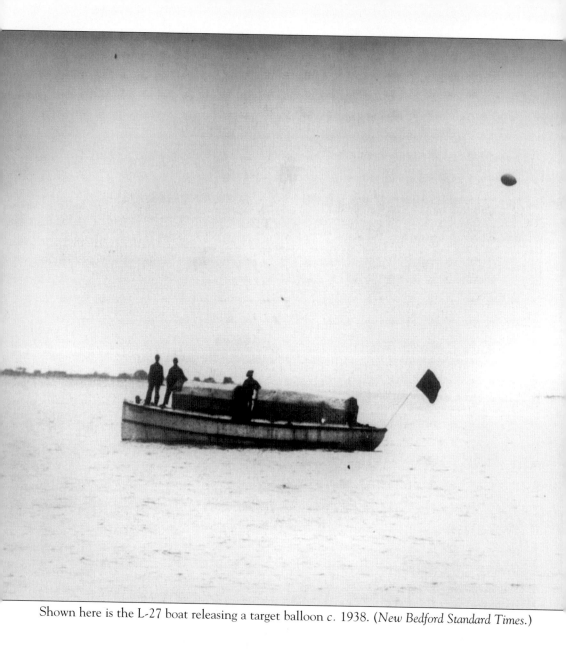

Shown here is the L-27 boat releasing a target balloon *c.* 1938. (*New Bedford Standard Times.*)

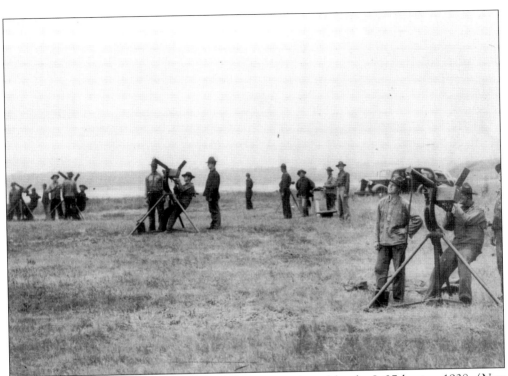

Soldiers at target practice shoot at the balloon just released by the L-27 boat c. 1938. (*New Bedford Standard Times.*)

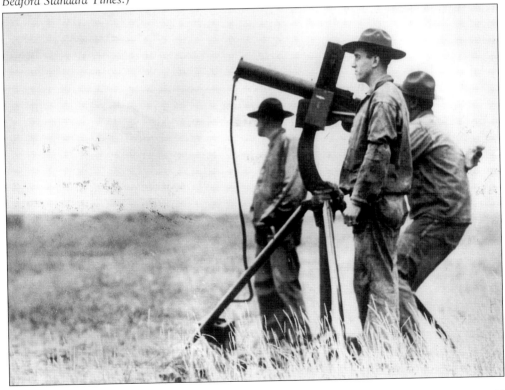

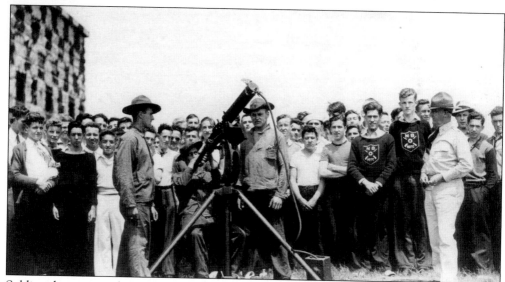

Soldiers demonstrate how to shoot the water-cooled machine gun for the New Bedford Reserve Officer Training Corps (ROTC) *c.* 1938. (*New Bedford Standard Times.*)

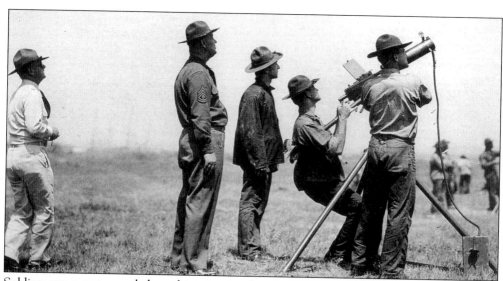

Soldiers use a water-cooled machine gun to fire at a target balloon *c. 1938* (*New Bedford Standard Times.*)

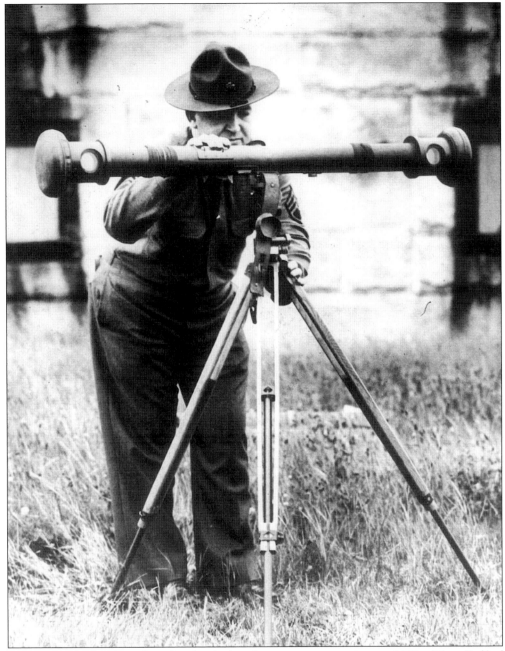

A sergeant looks through a height finder during target practice *c.* 1938. (*New Bedford Standard Times.*)

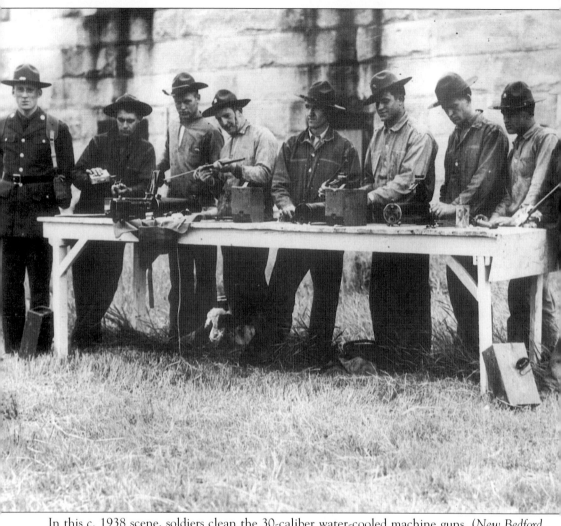

In this *c.* 1938 scene, soldiers clean the 30-caliber water-cooled machine guns. (*New Bedford Standard Times.*)

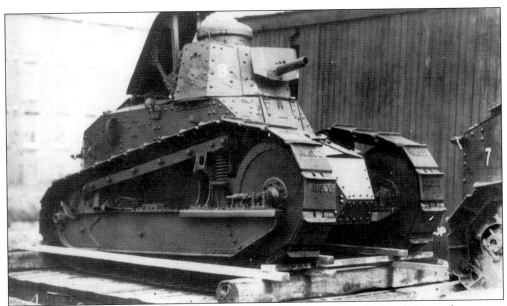

Shown here is a tank about to be delivered to Fort Rodman, New Bedford, Massachusetts, c. 1938. (Author's collection.)

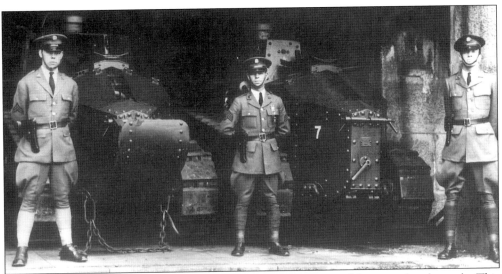

Tanks were stored in the casemates of the granite fort, protected by stern-faced guards. This photograph was taken 1938. (Author's collection.)

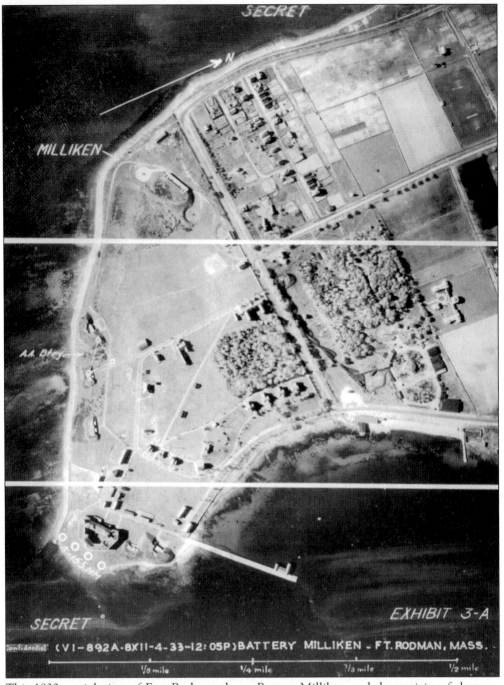

MILLIKEN

A.A. Btry

4-155 M.M.

EXHIBIT 3-A

Confidential (VI-892A-8XII-4-33-12:05P) BATTERY MILLIKEN - FT. RODMAN, MASS.

⅛ mile ¼ mile ⅜ mile ½ mile

This 1930s aerial view of Fort Rodman shows Battery Milliken and the antiaircraft battery. (Author's collection.)

Five
WORLD WAR II
(FORT RODMAN)

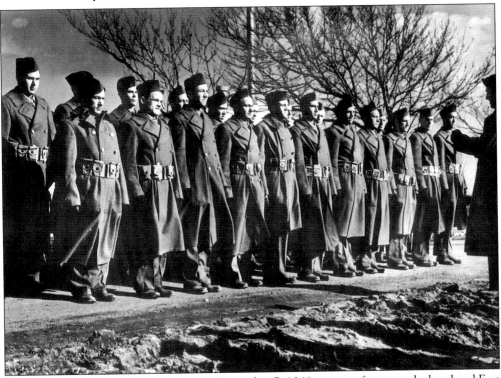

Following the attack on Pearl Harbor on December 7, 1941, a state of war was declared and Fort Rodman responded with all other coastal forts. Guards were anxious and suspicious of all movement, tensions ran high, and the ordnance was frequently and lovingly checked by the battery commander, as well as by the lowliest cannoneer. In this photograph, soldiers line up for the roll call and get the orders of the day. (Author's collection.)

During the beginning of World War II, the post was changing. New barracks and other buildings were being built to accommodate the new soldiers for war. These photographs show the construction project of barracks being built at Fort Rodman. (*New Bedford Standard Times.*)

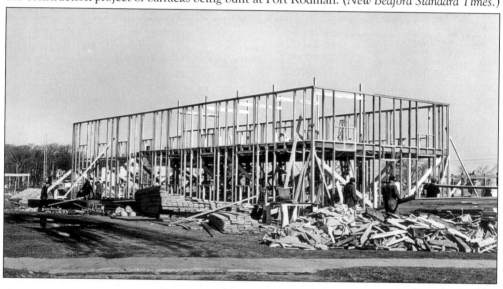

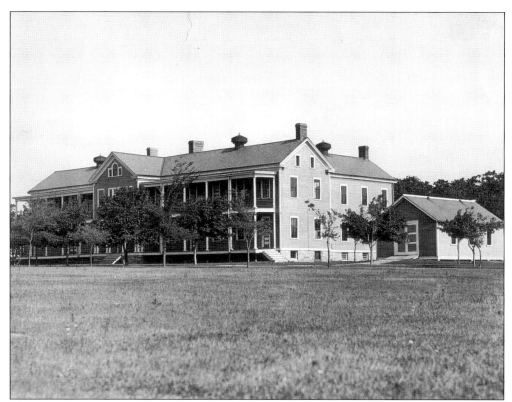

This photograph shows the main barracks at Fort Rodman *c*. 1941. (Author's collection.)

This *c*. 1941 view shows one of the administration buildings at Fort Rodman. (Author's collection.)

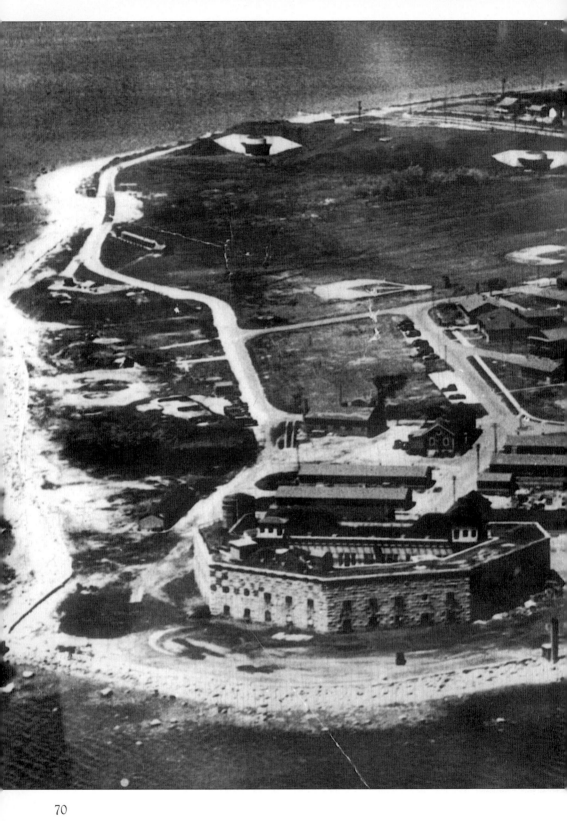

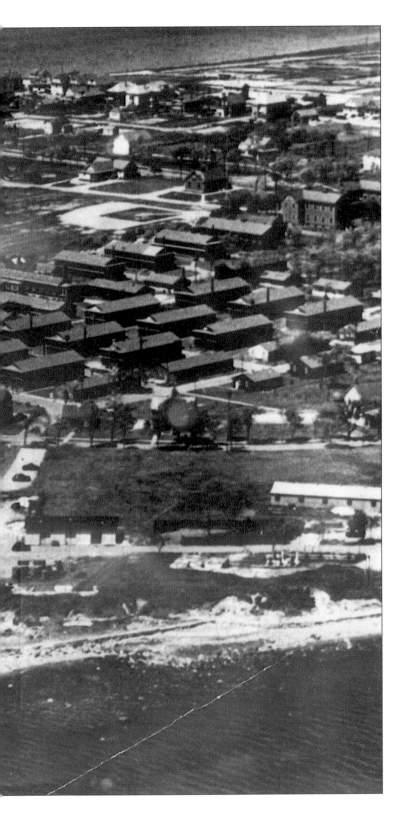

This is an aerial photograph of Fort Rodman during World War II. Battery Milliken is visible at the rear. (Author's collection.)

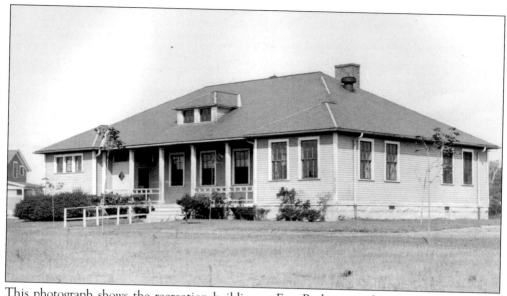

This photograph shows the recreation building at Fort Rodman in the 1940s. (*New Bedford Standard Times.*)

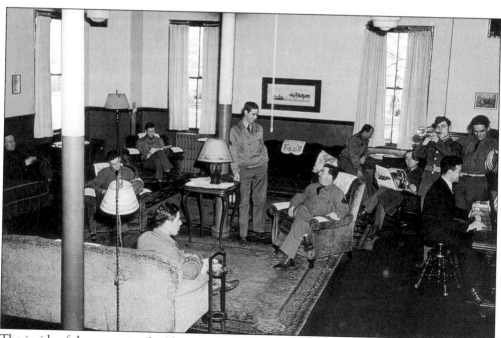

The inside of the recreation building was called the Day Room. Many soldiers spent their free time here, reading, listening to music, or relaxing. (*New Bedford Standard Times.*)

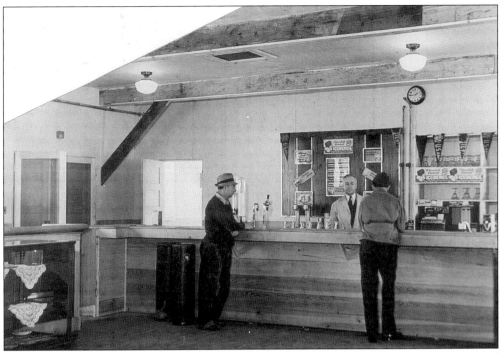

This is the soda fountain that was in the Fort Rodman Base Exchange *c.* 1940s. (*New Bedford Standard Times.*)

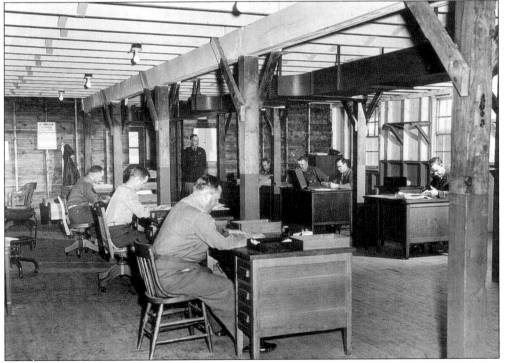

Soldiers process forms and requests in one of the administration buildings at Fort Rodman. (*New Bedford Standard Times.*)

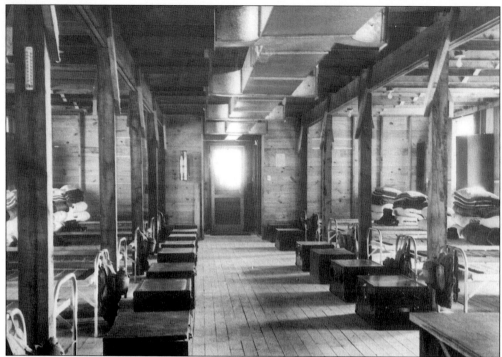

This photograph shows the living conditions for the soldiers stationed at Fort Rodman during World War II. Notice the lack of insulation on the wall. (Author's collection.)

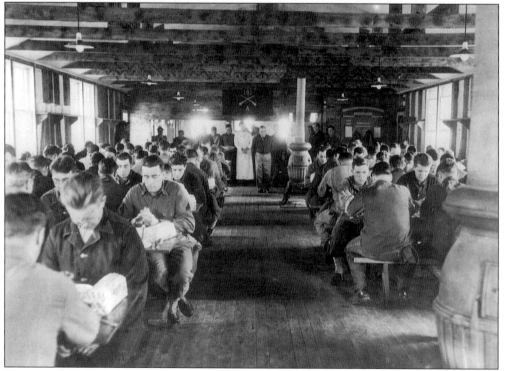

Shown is the mess hall of A Company, 181st Infantry at Fort Rodman. (Author's collection.)

Pictured in this scene are the parade ground, the barracks, and a roller coaster in the distance. (*New Bedford Standard Times.*)

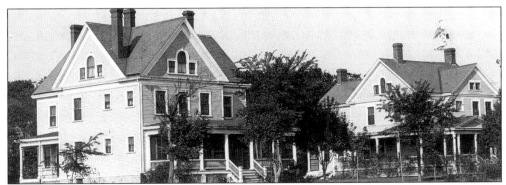

These are two of the four houses that were in Officers Row at Fort Rodman. (Author's collection.)

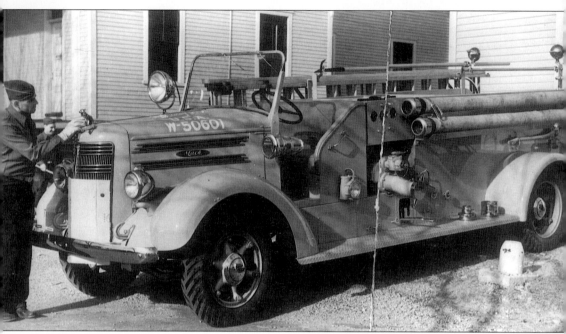

This c. 1943 view shows the 1940 Mack fire truck at the Fort Rodman Fire Station. (Author's collection.)

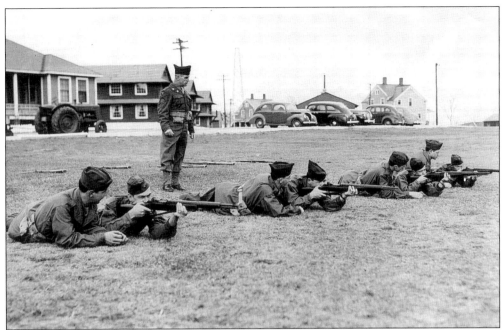

Soldiers are seen at the rifle range at Fort Rodman, with newly issued M-1 Garand rifles. (Author's collection.)

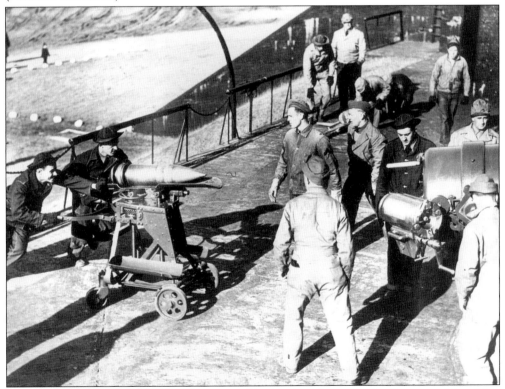

Men from the 23rd Coast Artillery Regiment (Fort Rodman) practice loading one of the eight-inch disappearing guns at Battery Barton. (Marty Dwyer collection.)

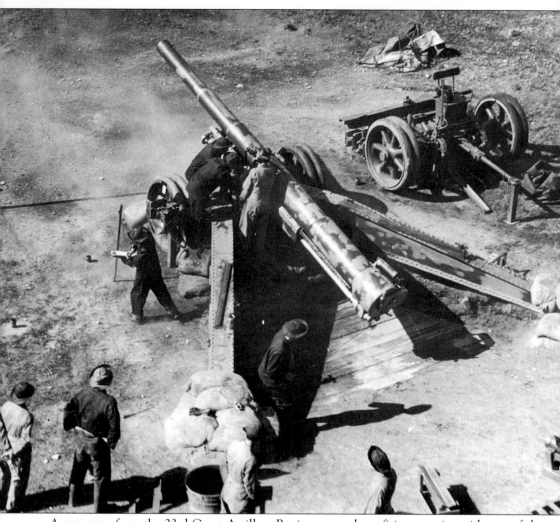

A gun crew from the 23rd Coast Artillery Regiment conducts firing practice with one of the 155-mm rifles. (Marty Dwyer collection.)

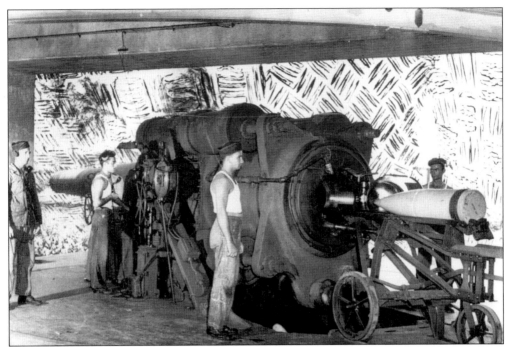

This remarkable wartime image, taken *c.* 1942, shows the gun crew during a practice artillery drill with one of the camouflaged, casemated 12-inch guns of Battery Milliken in its protected gun room. (Author's collection.)

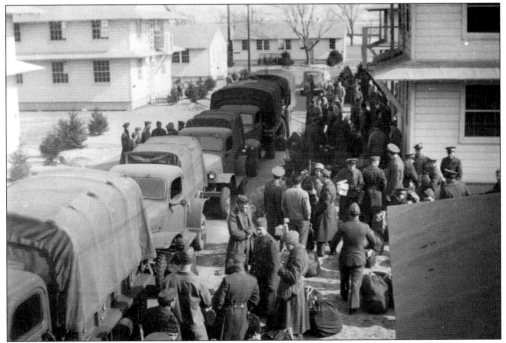

Military personnel prepare to leave by troop truck in January 1942. (Author's collection.)

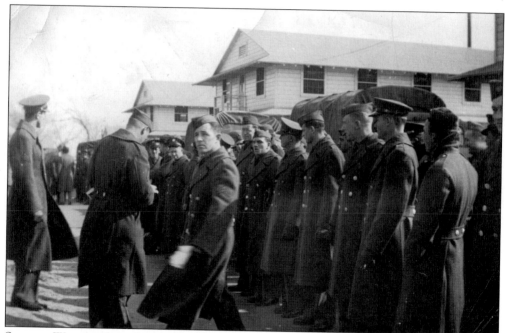

Sergeant Wentworth is taking roll call of the men ready to leave Fort Rodman in January 1942. (Author's collection.)

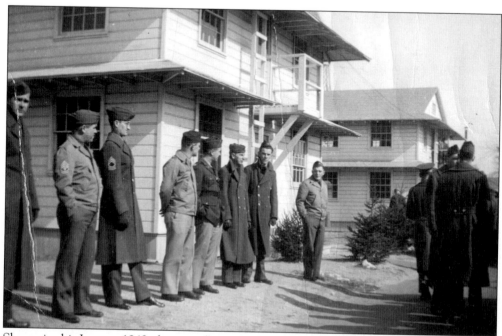

Shown in this January 1942 photograph are Captain McQuine, Lieutenant Kabnell, and some of the staff from Fort Rodman. (Author's collection.)

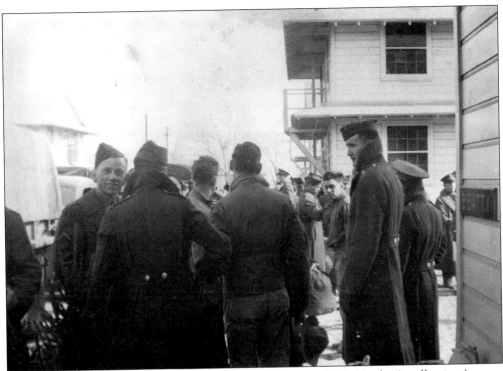

Boarding trucks are ready to leave Fort Rodman in January 1942. (Author's collection.)

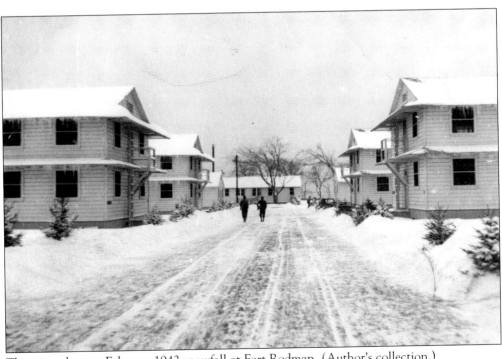

This view shows a February 1942 snowfall at Fort Rodman. (Author's collection.)

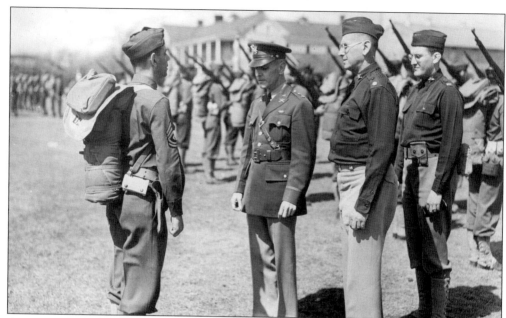

At attention is 1st Sgt. Joseph F. Furtado (left), a 16-year army veteran at Fort Rodman receiving the once-over from Lt. Col. Henry D. Cassard, 9th Coast Artillery (Harbor Defenses), Fort Banks, Winthrop. Cassard conducted a general inspection of the 23rd Coast Artillery, an annual army procedure dating back to post-Revolutionary days. Escorting the visiting officer, representative of Lt. Gen. Hugh A. Drum, 1st Army commander, are Lt. Col. Charles J. Herzer, fort commandant (second from right) and 1st Lt. James H. Harvey, adjutant of the 23rd. In the background, troops from headquarters and Batteries A, B, and C are in heavy marching order for the inspection. (Author's collection.)

Officers of the 23rd Coast Artillery stand at attention during the general inspection. (Author's collection.)

Officers and noncommissioned officers of the 23rd Coast Artillery at Fort Rodman pose with the Harbor Defenses logo of New Bedford Battery B. (Author's collection.)

These two images depict men from the 23rd Coast Artillery Regiment putting on an exhibition of drilling for the residents of New Bedford. (*New Bedford Standard Times.*)

Six

WORLD WAR II (SUBPOSTS)

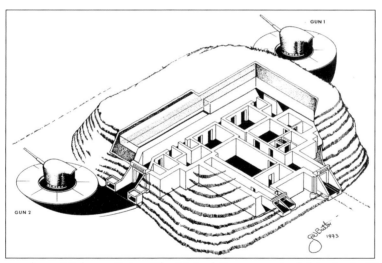

This diagram shows Mishaum Point. The United States acquired this site in 1943 and 1944. Strategically located in Dartmouth, the site consisted of 26 acres. The army used the site, known as the Mishaum Point Fire Control Station, during World War II as part of the Harbor Defenses of New Bedford and built a battery for two six-inch guns, barracks, an infirmary, a fire station, a radar-operations building, a radar tower, two generator buildings, and nine other temporary buildings. After the initial acquisition of the land, temporary emplacements were constructed at the point for two 155-mm GPF guns and were removed upon completion of Battery 210. Battery 210 was built for two six-inch rifled guns on a barbette-type carriage equipped with four-inch-thick steel shields. The guns were mounted on two concrete gun blocks that were approximately 200 feet apart. Between them, in a reinforced concrete structure covered with earth, were powder magazines, shell rooms, compressor rooms, storerooms, a plotting room, a radio room, and a power plant for the battery. (Gerald Butler.)

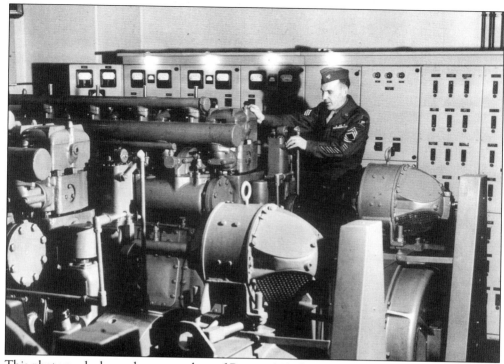

This photograph shows the power plant of Battery 210. (*New Bedford Standard Times.*)

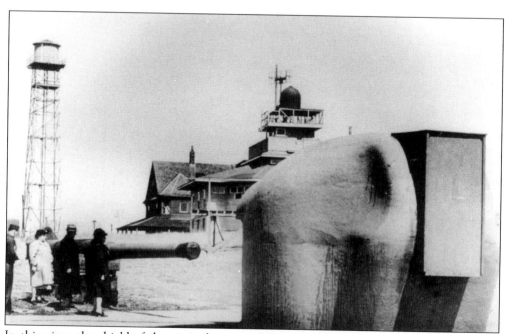

In this view, the shield of the six-inch gun and the six-inch gun tube sit on blocks. In the background the Harbor Entrance Control Post (HECP) and the SCR-296A radar are camouflaged to look like a water tower. (*New Bedford Standard Times.*)

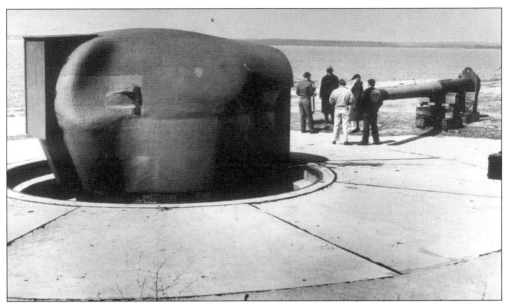

Shown in this photograph are the No. 2 gun tube and shield on blocks, in preparation for dismantling after World War II. (Author's collection.)

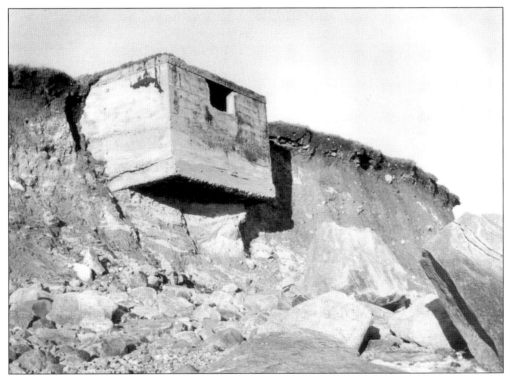

This photograph shows one of the abandoned concrete outbuildings at Mishaum Point, suffering from beach erosion. (Author's collection.)

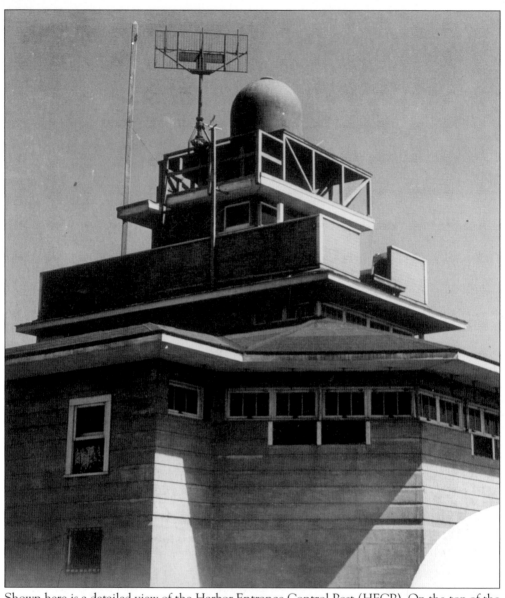

Shown here is a detailed view of the Harbor Entrance Control Post (HECP). On the top of the building are a radar dome and an antenna. (Author's collection.)

These are two *c.* 1945 views of West Island's fire control tower and antiaircraft observation station. The tower was 51-feet-high with outside dimensions of 20 feet by 20 feet. The first level of the tower was used for Battery Milliken and the second level was used for Battery 210 (Mishaum Point). A mess hall and barracks were constructed at this site but were destroyed before September 1944. (Author's collection.)

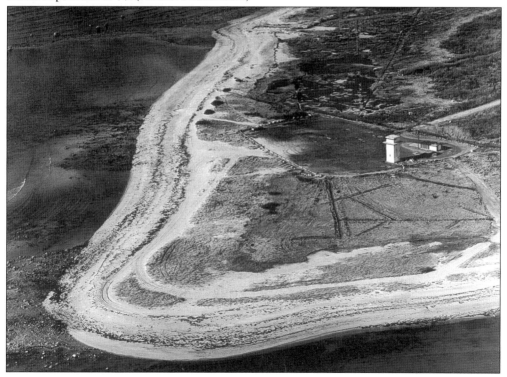

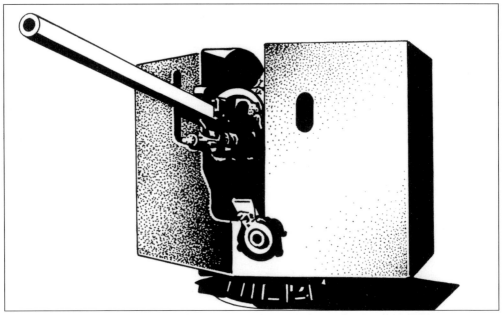

The army built a site known as Butler's Point Anti-Motor Torpedo Boat (AMTB) Battery 934, with temporary barracks, a mess hall, and a battery commander's (BC) station. The army had installed two 90-mm M1 guns on fixed mounts and two 90-mm guns on temporary mounts. the Harbor Defenses of New Bedford had three other AMTB batteries: Battery 931 Barney's Joy Point, Battery 932 Cuttyhunk Island, and Battery 933 Nashawena Island. All of these batteries had a fire control station with barracks and other buildings. Butler's Point battery also had two 155-mm guns on concrete mounts and magazines. The top picture is a drawing of a 90-mm gun that would have been used by the AMTB. The lower picture shows a 155-mm gun of the type that would have been at Butler's Point (Battery 934). (Gerald Butler, top; USACE, Cape Cod bottom.)

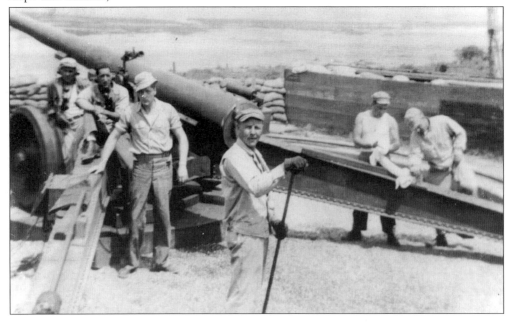

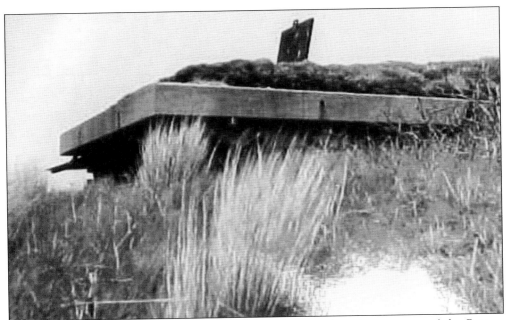

At Cuttyhunk Island and Naushon Island, the fire control stations were used for Battery Milliken and Battery 210 Mishaum Point and consisted of barracks and an observation station. The Cuttyhunk Island installation was also used as a group station (Harbor Defenses of New Bedford). Called "manholes" by operating personnel, the fire control stations were built into the ground, for purposes of protection and maximum viewing of Buzzards Bay. (Author's collection.)

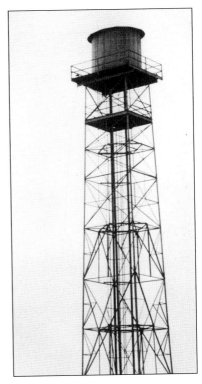

Shown here is the SCR-296A radar tower at Cuttyhunk Island, camouflaged as a water tower. (General Services Administration.)

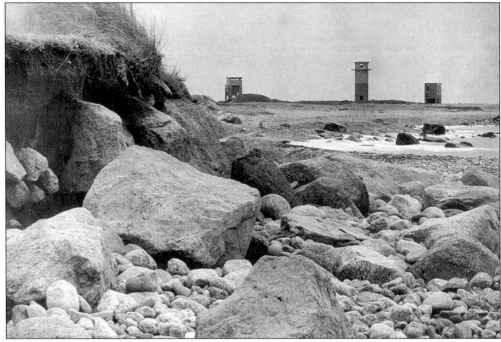

This photograph shows the three towers on Gooseberry Neck at Westport. The middle station was the fire control tower used for the Harbor Defenses of New Bedford, Battery Milliken and Battery 210 Mishaum Point. The two other towers were used for the Harbor Defenses of Narragansett Bay. This site also had barracks, a mess hall, and other buildings for the soldiers stationed there. (*New Bedford Standard Times.*)

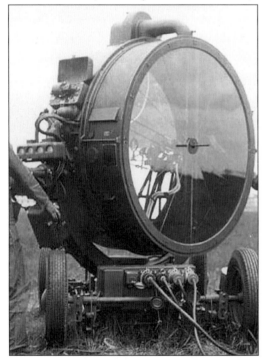

The Harbor Defenses of New Bedford maintained six searchlights stations: lights Nos. 1and 2 were at Cuttyhunk Island, lights Nos. 3 and 4 were at Mishaum Point, light No. 5 was at Fort Rodman, and light No. 6 was at the fire control station on West Island. This picture shows a typical 60-inch searchlight that would have been used at these sites. (Author's collection.)

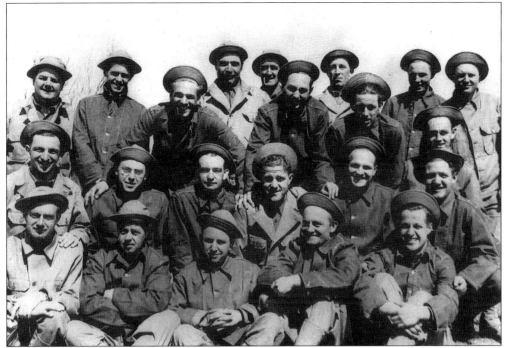

Late in 1941, Battery C of the 241st Coast Artillery Corps (Boston) formed an encampment at Sagamore Hill. This site had two 155-mm guns on Panama mounts, with 10 to 12 buildings, consisting of barracks and other miscellaneous structures. This station was formed to protect the Cape Cod Canal from enemy attacks. Shown are some of the men who were stationed at the site. (USACE.)

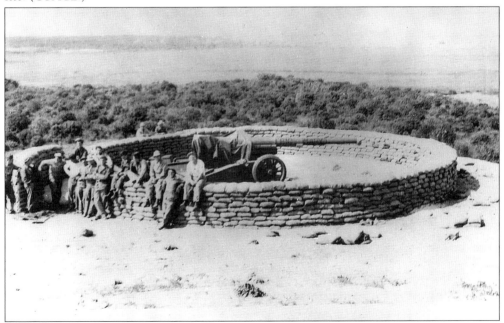

Shown here is one of the 155-mm guns at Sagamore Hill, showing sandbags around the gun to protect against enemy gunfire. (Sgt. L. Salza and USACE.)

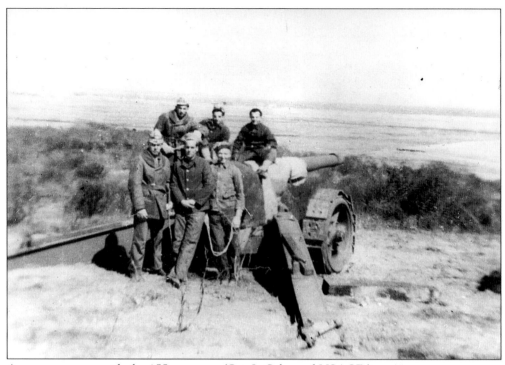

A gun crew poses with the 155-mm gun. (Sgt. L. Salza and USACE.)

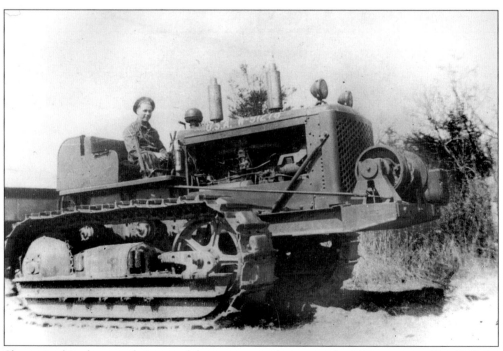

Shown in this photograph is one of the tractors used to move the 155-mm guns. (Sgt. L. Salza and USACE.)

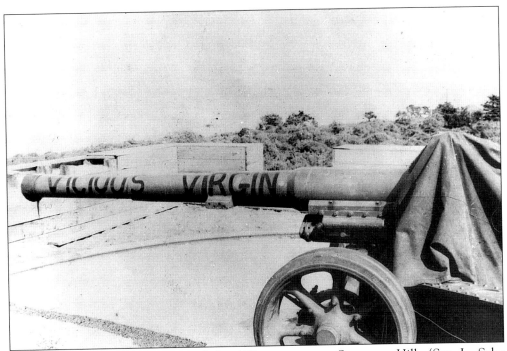

This is a detailed view of one of the 155-mm guns at Sagamore Hill. (Sgt. L. Salza and USACE.)

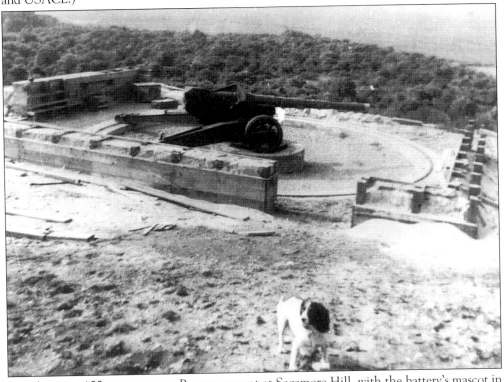

Seen here is a 155-mm gun on a Panama mount at Sagamore Hill, with the battery's mascot in the foreground. (Sgt. L. Salza and USACE.)

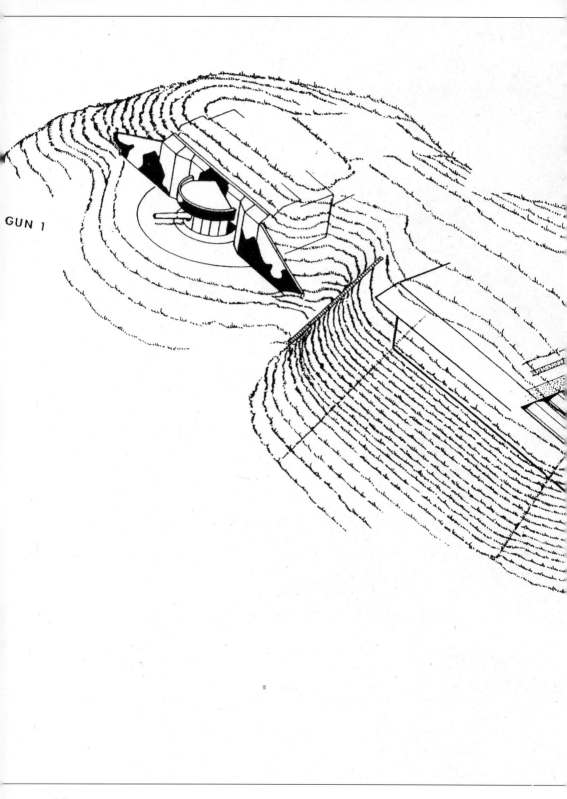

GUN 1

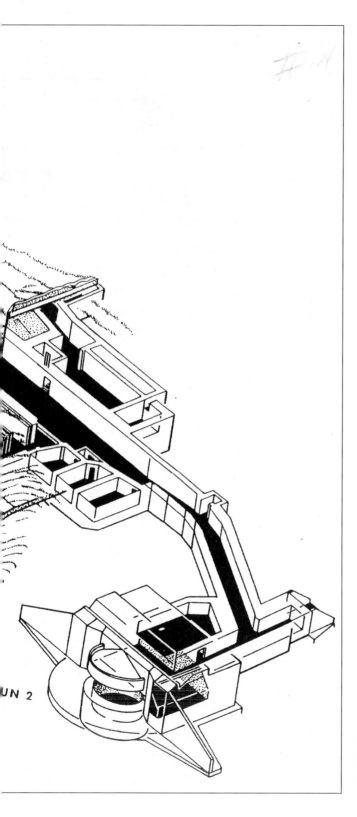

UN 2

This is a diagram of Battery Milliken when it was casemated during World War II. (Gerald Butler.)

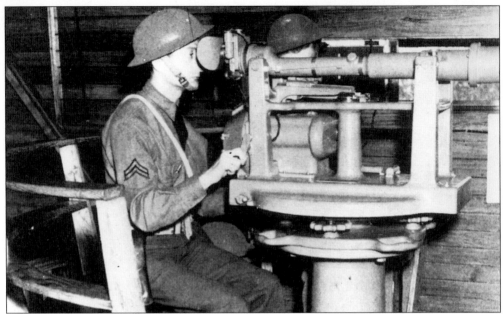

The fire control station at Fort Rodman was located on top of the old stone fort, built in World War I, and used through World War II. The station was a two-floor structure; the first floor was used as storage, and the second floor was used as the observation post. In the observation station, soldiers would use different types of instruments, including an Azimuth Instrument (AI) and a Depression Position Finder (DPF). This image shows soldiers using a DPF that would have been in the station at Fort Rodman. (Author's collection.)

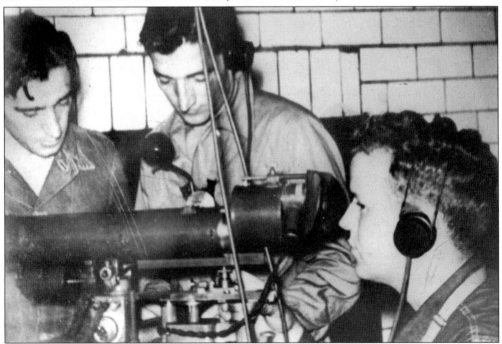

In this photograph, soldiers use a DPF. As a target was tracked, one man looked through the scope, while the other man radioed the headings to a plotting room. (Author's collection.)

Seven

THE POSTWAR AND COLD WAR PERIODS

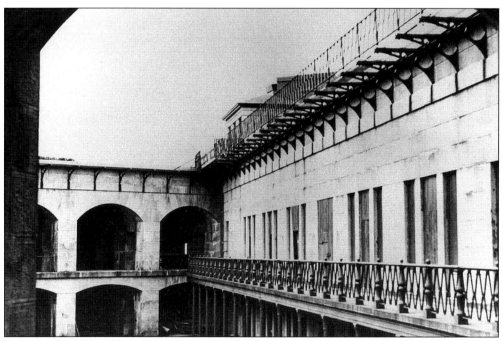

At the end of World War II, studies indicated that "seacoast forts played an important part in the wars of the 17th, 18th and 19th centuries. World War I witnessed the last significant encounters between seacoast fortifications and naval crafts, but the pattern was different in World War II; fixed harbor defenses were powerless to prevent the destruction of our fleet at Pearl Harbor, and the Japanese shipping at such places as Truk and Manilla Bay, Corregidor and Singapore fell without firing a shot at a hostile naval vessel. Fixed seacoast artillery did not seriously threaten allied landings in Southern France or Normandy." (Author's collection.)

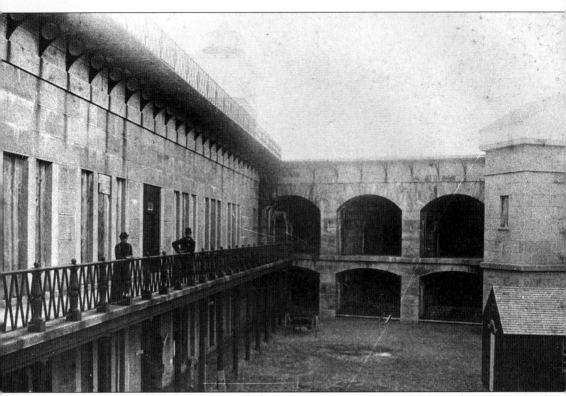

The study concluded that fixed seacoast defenses had been made important in World War II by air power and amphibious maneuver. Once air superiority was achieved, amphibious landings could be made anywhere. Thus, air power had become the primary means of defense of coastal cities and naval bases against hostile naval craft. The study pointed out that all the defense measures, except for controlled mines and fixed guns, were the navy's responsibilities. There was a dual responsibility, which in the interest of economy and efficiency was reduced to one agency. Thus, it was logical to make the navy responsible for the protection of the harbors and installations incident thereto against surface and subsurface craft, and to have the army continue to provide and operate mobile land forces required for direct defense of the coast. (Author's collection.)

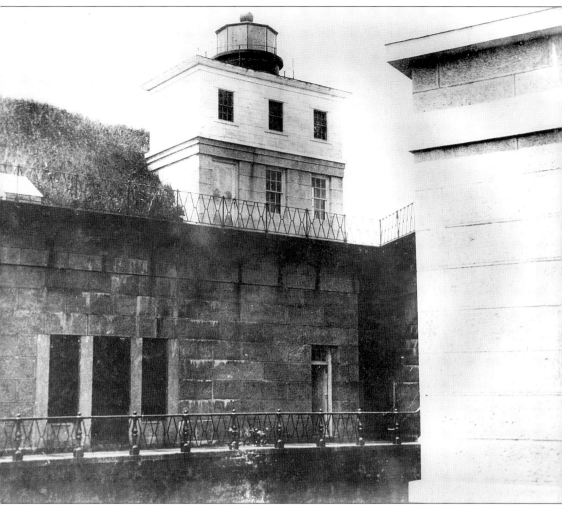

Recommendation was approved, and on May 14, 1948, the adjutant general wrote to the commanding generals of the 1st, 2nd, and 6th Armies: "Effective May 5, 1948, the permanently emplaced seacoast artillery batteries are to be placed in the category of surplus and will be disposed of in accordance with applicable laws and regulations." Two years later in General Orders No. 23, Army Organization Act of 1950, the army eliminated the Coast Artillery Corps. After 160 years, U.S. reliance on permanent fortifications to provide deterrence and defense to its rivers and harbors had come to an end. This picture shows the old lighthouse atop the old stone fort, used as a signal station and a meteorological station during World Wars I and II. (Author's collection.)

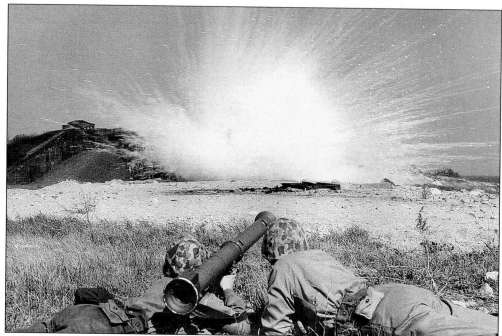

After the Army Organization Act of 1950, Fort Rodman was used as a reserve-training center for U.S. Army, U.S. Navy, U.S. Marine, and U.S. Coast Guard Reserve units. In this image, Marines use one of its training areas, firing a bazooka rocket at a target. (*New Bedford Standard Times.*)

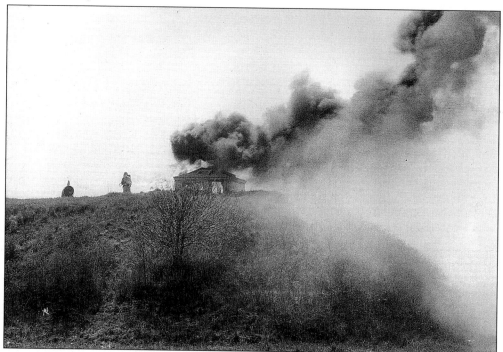

Shown here is a marine flamethrower, during a mock attack on a building at Fort Rodman. (*New Bedford Standard Times.*)

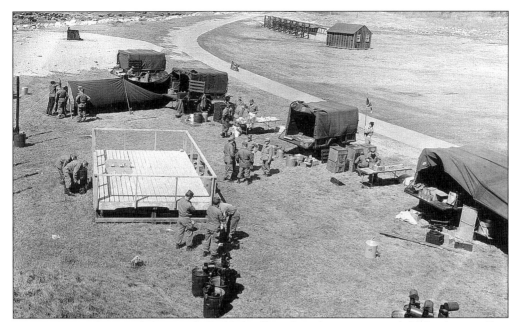

National Guardsmen of the 212th Field Artillery Battalion set up a field kitchen at Fort Rodman during a six-hour drill. The knowledge of military subjects learned at weekly drill sessions was reinforced during the battalion's annual summer encampment. (*New Bedford Standard Times.*)

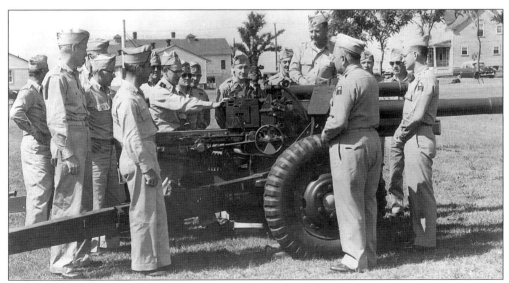

U.S. Army Reserve officers are inspecting a 105-mm field artillery piece at Fort Rodman during the 1950s. (Author's collection.)

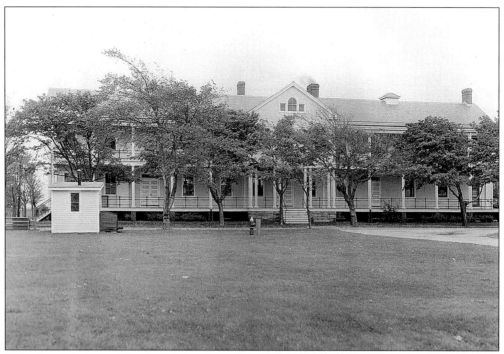

This photograph is of the main barracks at Fort Rodman (T-10), used by the various Reserve units that occupied the fort during their training. (Author's collection.)

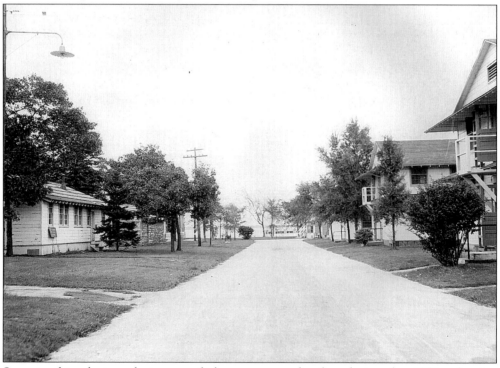

Seen in this photograph is one of the streets at the fort during the 1950s, showing refurbished World War II (right), used by different units at Fort Rodman. (Author's collection.)

Eight
THE PRESENT

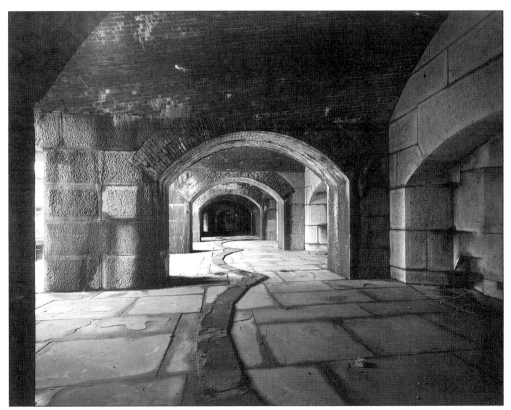

Shown here is an interior view of the front casemated gun rooms on the second tier of the granite fort. Notice the circular metal runners on the floor remaining in place. The rear wheels of the Civil War casemate cannons carriages traversed upon these rather than wear the stone floor into grooves. (Author's collection.)

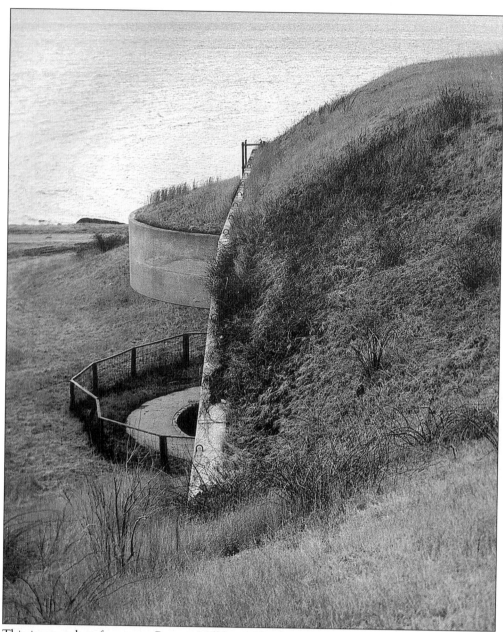

This image taken from atop Battery Milliken's No. 1 gun—now empty—shows detail of the canopy. (Author's collection.)

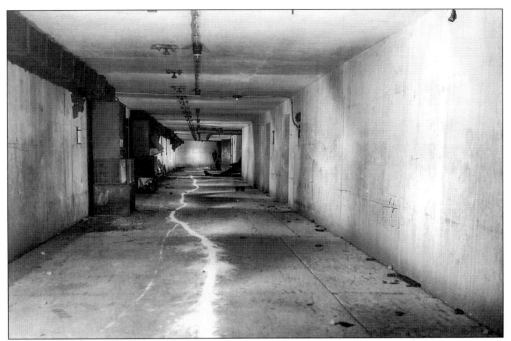

This is a view of the main corridor of Battery Milliken. On the left is one of the air-conditioning units that were used in the battery for ventilation and heating. (Author's collection.)

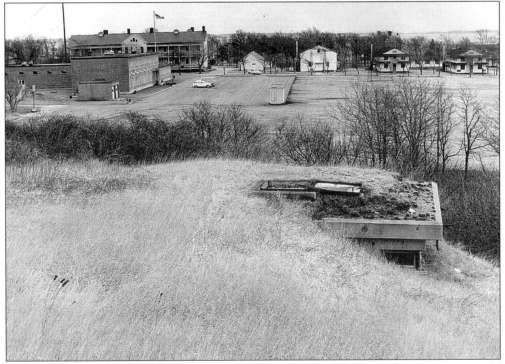

Seen here is a manhole-type observation post atop Battery Milliken, where spotters would observe targets for the gun battery. (Author's collection.)

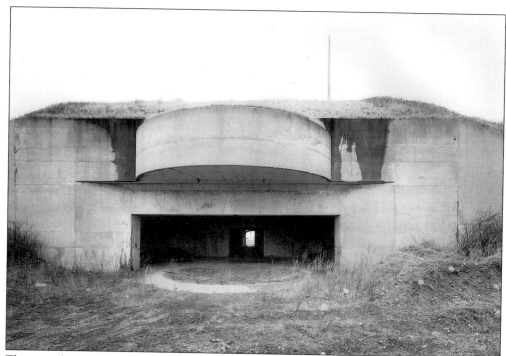

This is a photograph of Battery Milliken's empty gun room, where the gun would have been. (Author's collection.)

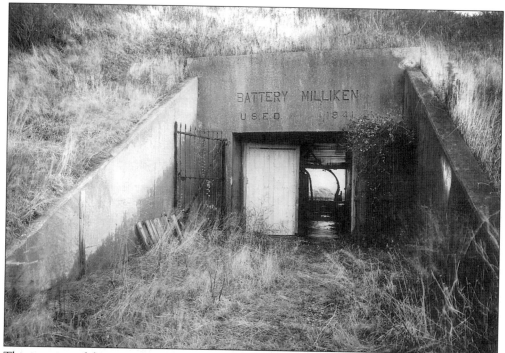

This is a view of the rear entrance to Battery Milliken. The "U.S.E.D." designates United States Engineer Department, and the date, 1941, indicates the year the battery was completed. (Author's collection.)

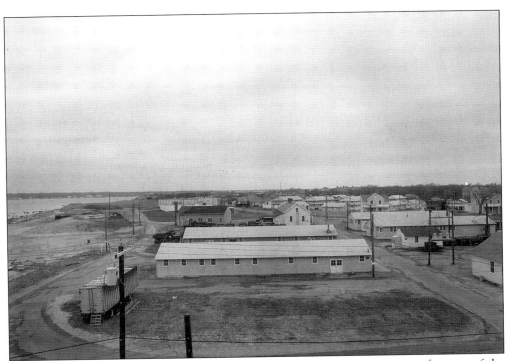

The post was in constant use as an organized Armed Reserve training station for arms of the service through the 1980s. These two photographs show the U.S. Army Reserve post during the 1970s, taken from atop the old stone fort. Throughout its history the fort has been associated with many distinguished persons: Gen. Ulysses S. Grant, Gen. Philip Sheridan, Gen. Douglas MacArthur, Hon. Elihu Root, and others. The stone fortress saw the heroes of war though it never saw the flames of battle. (Author's collection.)

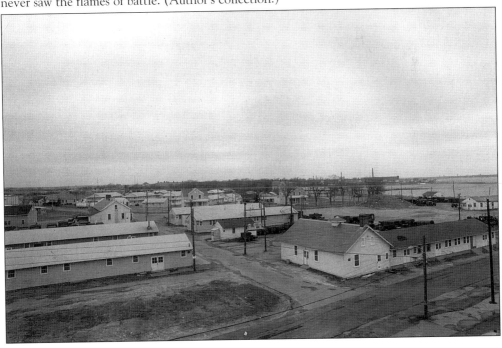

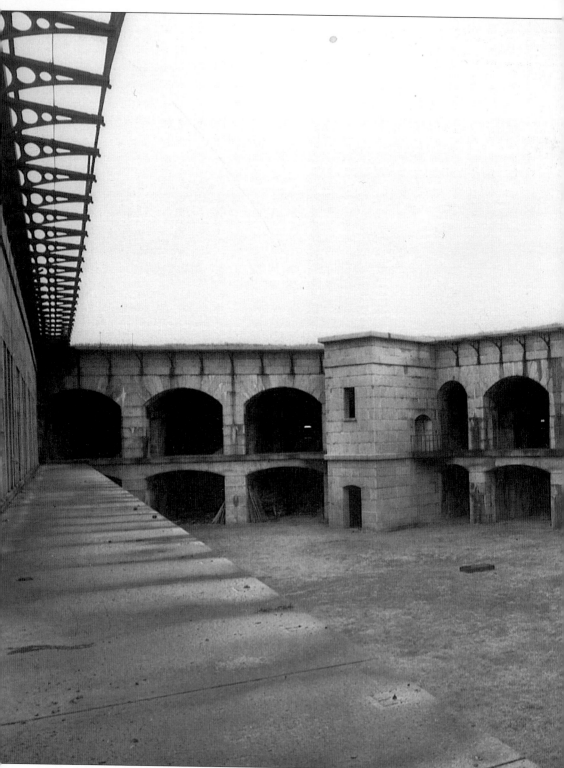

The excellent stonework of the old stone fort at Clark's Point is visible in this view from the

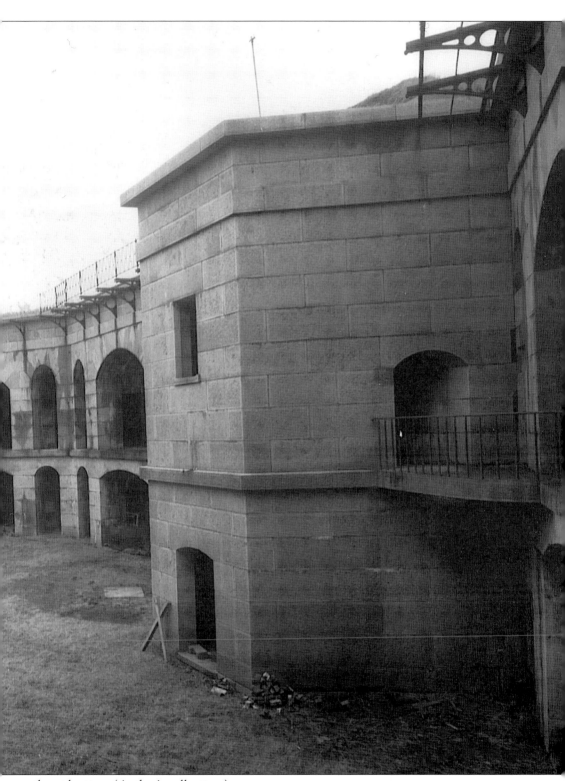

southeast bastion. (Author's collection.)

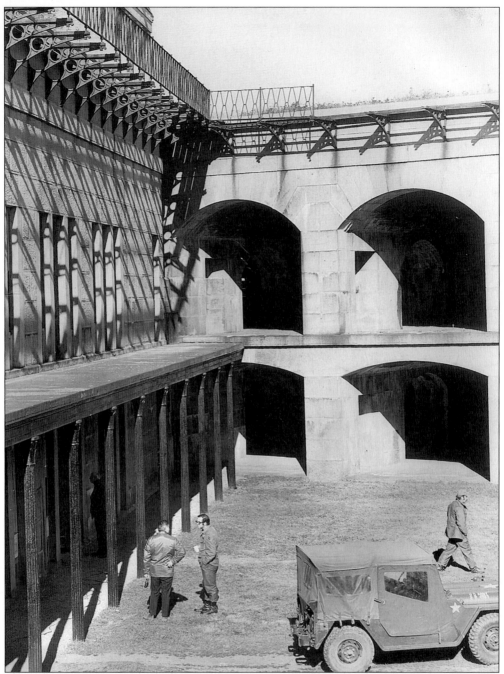

This photograph shows the interior of the old stone fort, with soldiers of the U.S. Army Reserve working inside during the 1970s. The soldier in the picture talking to Alfred K. Schroeder is Capt. Gerald Butler, U.S. Army Reserve, and curator of Fort Taber from 1972 to 1974. (Author's collection.)

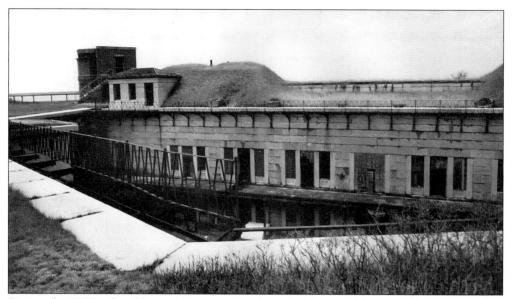

During the 1970s, the old stone fort was placed on the National Historical Register, as many people worked to restore its pristine look. This photograph shows the officers quarters on the second floor and the fire control tower on the third level. (Author's collection.)

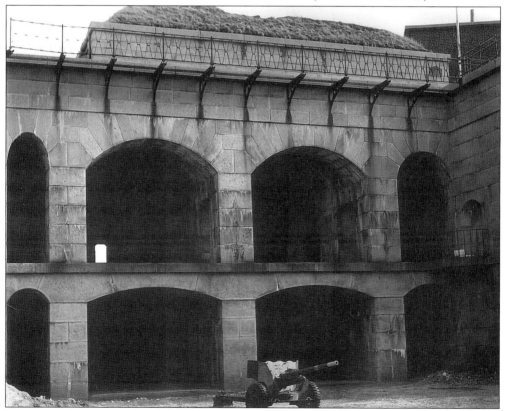

Casemates that once held the Rodman cannons now could only boast of a 57-mm antitank cannon on the parade ground. This photograph was taken c. 1974. (Author's collection.)

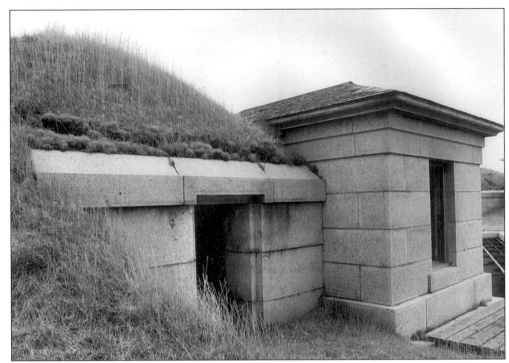

This is one of the third-level magazines of the old stone fort. The small building on the right of the magazine enclosed the metal staircase used by the officers. (Author's collection.)

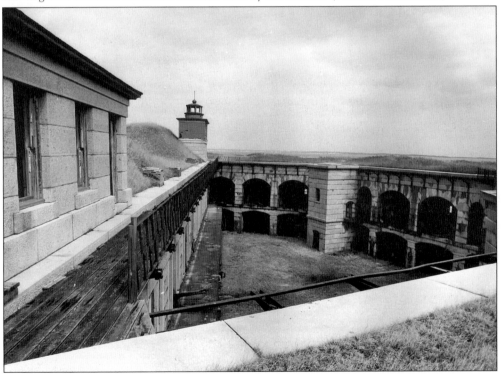

This is a 1972 view from the third level of the old stone fort. (Author's collection.)

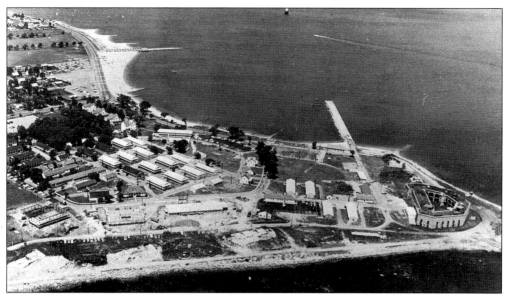

This aerial view of Fort Rodman shows the entire Army Reserve area and training facility. (Author's collection.)

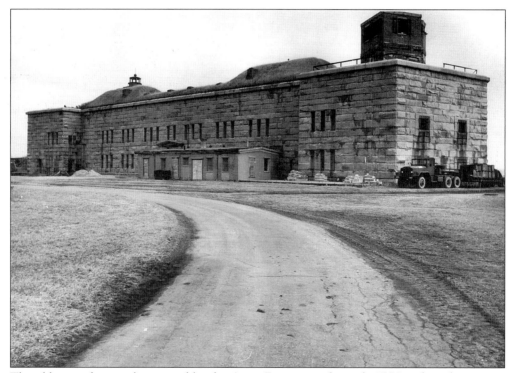

The old stone fort was being used by the Army Reserve in the early 1970s, when this picture was taken. (Author's collection.)

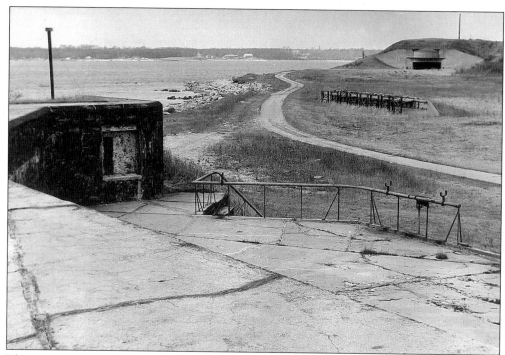

This is a view from Battery Barton on the west side of Fort Rodman, looking toward Clark's Cove and Battery Milliken. (Author's collection.)

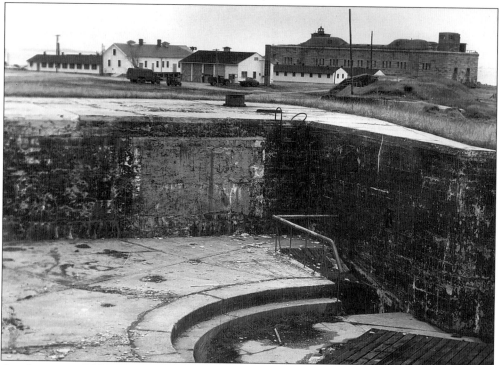

Another view of Battery Barton shows the gun platform and the old stone fort in the background. (Author's collection.)

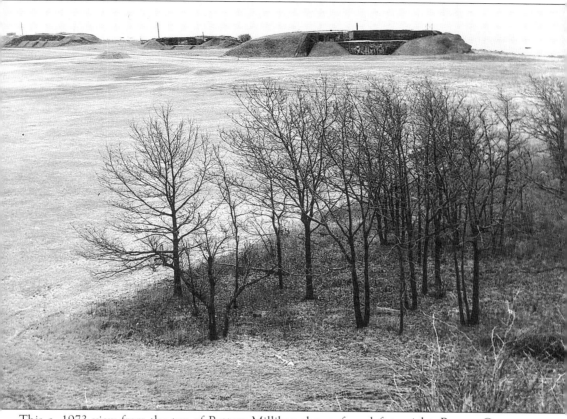

This *c.* 1973 view from the top of Battery Milliken shows, from left to right, Battery Cross, Battery Craig, and Battery Barton. (Author's collection.)

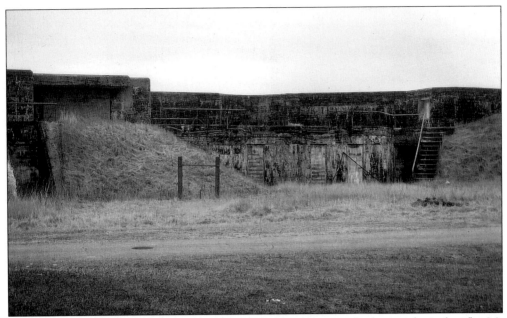

This view shows Battery Barton abandoned. This battery once had an eight-inch rifle, M-1888M2, mounted on an M-1896 disappearing carriage. (Author's collection.)

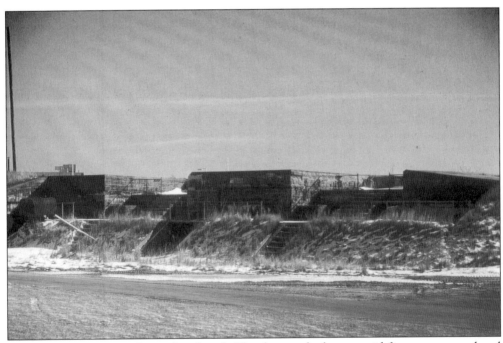

Shown here is Battery Cross abandoned. This battery had two rapid-fire guns on pedestal mounts. (Author's collection.)

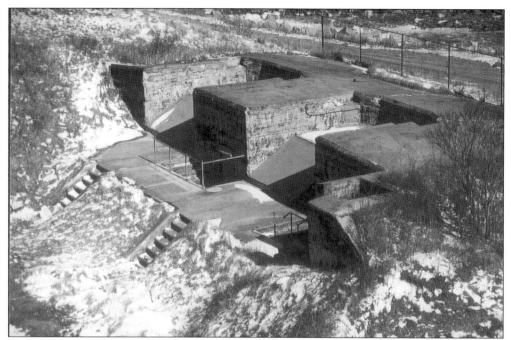

These two views of Battery Craig were taken *c.* 1974. This abandoned battery had three-inch rapid-fire guns on pedestal mounts. (Author's collection.)

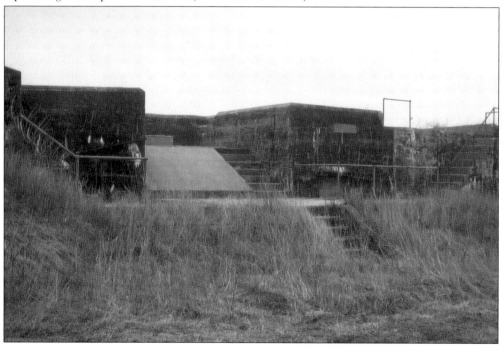

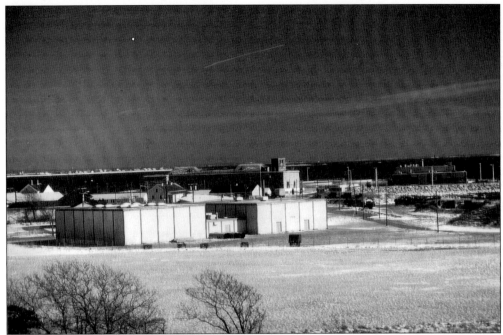

This c. 1974 view was taken from Battery Milliken. It shows the U.S. Army Reserve Center, with the old stone fort in the background. On the right is the old New Bedford Wastewater Treatment Plant. (Author's collection.)

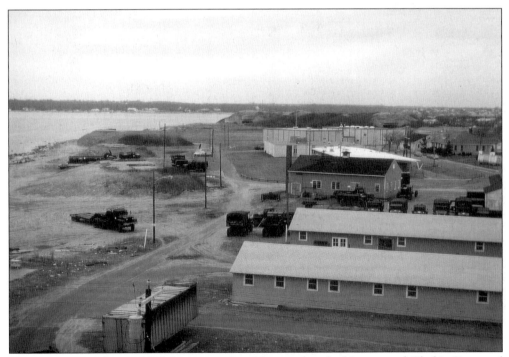

This image was taken c. 1972 from atop the old stone fort, looking toward Clark's Cove and Battery Milliken. (Author's collection.)

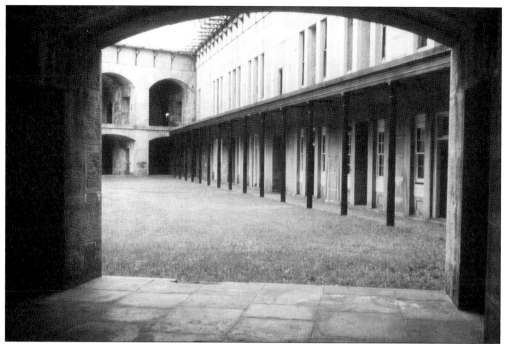

These are two interior views showing the restoration work done by the Fort Taber Historical Association in 1973. (Author's collection.)

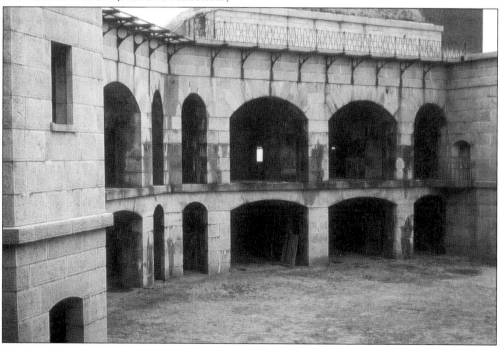

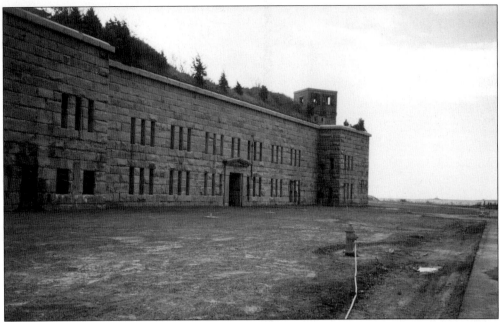

Fort Rodman and the old stone fort at Clark's Point have gone through many changes over the years. The military has left the fort and the city of New Bedford has removed the old wastewater plant and created a new facility with state-of-the-art equipment. The city has also created a park with walking paths, beaches, and a children's playground, and the old stone fort and batteries are being restored. The top image shows the back of the old stone fort, with newly planted grass. The lower image depicts the front of the old stone fort, where once stood the old wastewater plant. (Author's collection.)

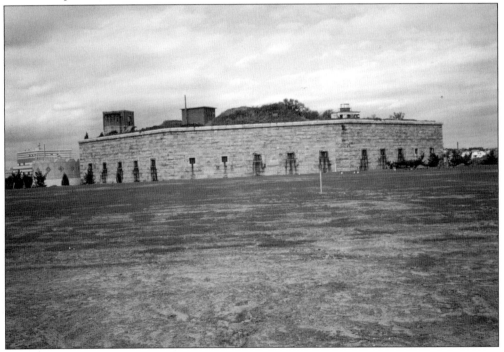

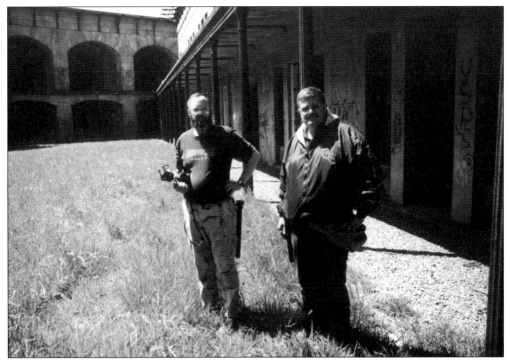

This is a photograph of Bolling W. Smith (left), editor for the Coast Defense Study Group, and author Christopher McDonald taking a tour of the old stone fort in the spring of 1999. (Author's collection.)

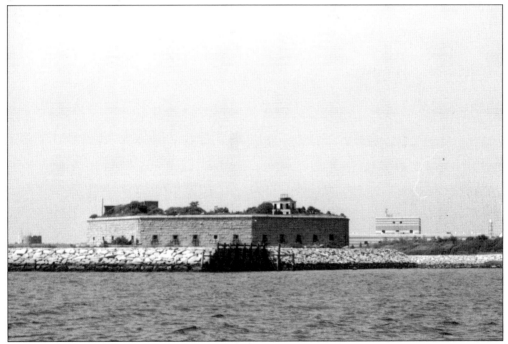

This is a recent view of the old stone fort at Clark's Point, taken from Buzzards Bay. In the background is the new wastewater treatment plant. (Author's collection.)

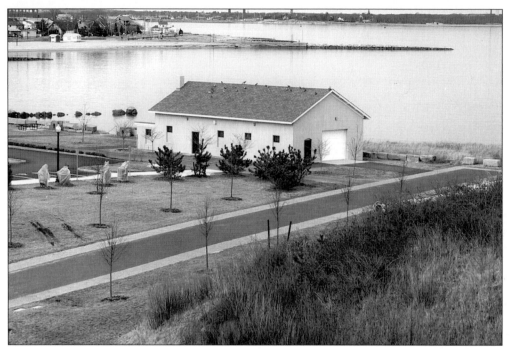

This image, taken from atop the old stone fort, shows the mine storehouse now used as the Community Boating Center. (Author's collection.)

Once the Fort Rodman Base Exchange, this building is being remodeled to become the new Fort Taber Museum and Fort Rodman Marine Educational Association Center.

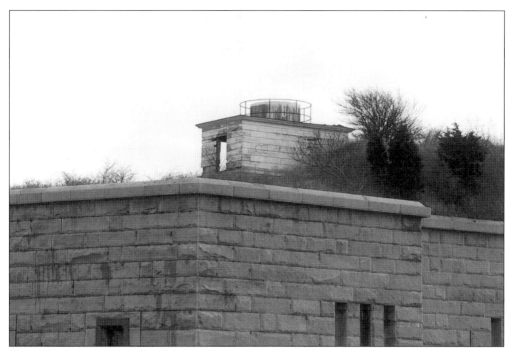

The old lighthouse atop the old stone fort is currently under restoration to return it to pristine condition. Once this is done, New Bedford will be the only city to have three restored lighthouses. (Author's collection.)

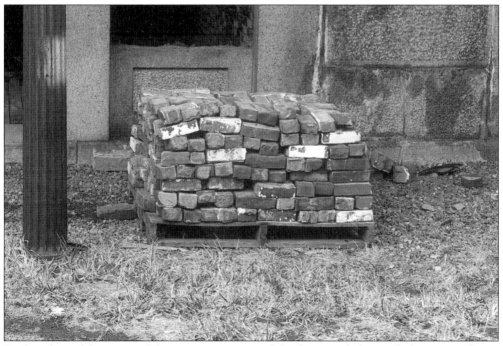

Bricks salvaged from one of the interior quarters of the fort sit piled on a skid, awaiting future restoration. (Author's collection.)

These two images show some of the work being done by the Bristol County Sheriff's Department's Graffiti Removal Unit. (Author's collection.)

This final image, looking toward Round Hill, Colonels Green's Estate, provides a spectacular view of Buzzards Bay. (Author's collection.)

ACKNOWLEDGMENTS

This book incorporates the contributions of many items from people who have memories of the military history of New Bedford, without whose help this work would not have been possible. I thank each of them for their assistance and encouragement during the various phases of the book. In particular, I would like to thank Gerald Butler, former curator of the Fort Taber Historical Association, author, and seacoast artillery historian. Additionally, Marty Dwyer and John D. Bowen for providing me with photographs and information on Fort Rodman and the fort at Clark's Point (Fort Taber). Other individuals who provided me with images and data are very much appreciated: Frank Kane, Dave Larsen USACE, Bolling Smith CDSG, Ranger Roger Hagen USACE, Thomas Vaughan CDSG, Steve Crossley FTHA, Robert C. Bromley, Sons of Union Veterans of the Civil War, and Jann Macomber and all the staff at Converse Photo Supply.

The following organizations and archives were instrumental in furnishing critical and factual data within their holdings: Fort Taber Historical Association, the National Archives and Records Administration, *New Bedford Standard Times*, New Bedford Free Public Library, Coast Defense Study Group, Council on Abandon Military Past, U.S. Army Military History Institute, Carlisle Barracks, and the General Services Administration, National Archives Record Center in Waltham.

Special appreciation to my parents, James McDonald and Barbara C. McDonald, two of the important people that made up the Fort Taber Historical Association in 1972, who interested me about the military history of New Bedford; and to my wife, Michelle, and my son, Matthew, the two who are helping me reach my goals with Fort Taber and the military history of the U.S. Army's Coast Artillery.

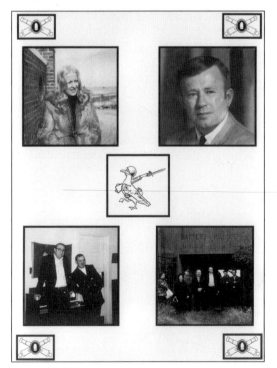

This page is dedicated to all the founders of the Fort Taber Historical Association, Inc. In the photograph (clockwise, from top left) are Barbara A. McDonald, James McDonald, Gerald Butler, Frank Kane, and Marty Dwyer. (Author's collection; photograph work by Jann Macomber, Converse Photo Supply.)